IMAGES
of America

BISHOP

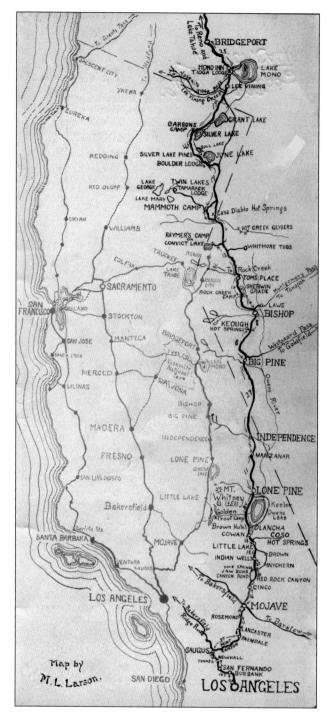

Bishop, California, is located in the Eastern Sierra Nevada, approximately 260 miles north of Los Angeles. (Community Printing; map by M. L. Larson.)

ON THE COVER: Bishop brings its past along as it advances through the years. The cover image is from around 1952 and depicts something locals can relate to. On a drive in any direction out of Bishop, there are plenty of horses and mules to be seen. (Laws Museum Archive; photographer unidentified.)

IMAGES
of America

BISHOP

Pam Vaughan, Brendan Vaughan
and the Laws Railroad Museum

ARCADIA
PUBLISHING

Published by Arcadia Publishing
Charleston, South Carolina

Printed in the United States of America

Library of Congress Control Number: 2010934150

For all general information, please contact Arcadia Publishing:
Telephone 843-853-2070
Fax 843-853-0044
E-mail sales@arcadiapublishing.com
For customer service and orders:
Toll-Free 1-888-313-2665

Visit us on the Internet at www.arcadiapublishing.com

In memory of the early peoples of the Owens
Valley who struggled to survive.

CONTENTS

Acknowledgments 6

Introduction 7

1. Deepest Valley 9

2. The Story Begins 17

3. Early Settlers 23

4. A Sense of Community 29

5. Bishop Folk 47

6. Making a Living 67

7. Laws 83

8. Recreation 91

9. A Tribute to the Sierra Mules 103

10. Life on the Range 113

Bibliography 127

About the Organization 127

ACKNOWLEDGMENTS

We want to thank Barbara Moss, director of the Laws Railroad Museum and Historic Site; Howard Holland, Lincoln Stanley, Jim Morrow, Barbara Crosby, Ruth Nielson, and Max Cox of the Laws Railroad Museum; Chris Langley, executive director of the Jim and Beverly Rogers Film Museum, Lone Pine; Roberta Harlan and Jon Klusmire, Eastern California Museum, Independence, California; Bishop Chamber of Commerce; Bonnie Ketterle Kane, Ridgecrest Communities Museum and Historical Society; Chief Ray Seguine, assistant chief Pat O'Neil, Bishop Fire Department; Shirley (Whorff) Fendon, Fendon's Furniture; Kenneth Partridge, a founder of Mule Days and former owner of Glacier Lodge Pack Station; Kenneth Partridge Jr.; Sharon Partridge; Sarah Puckitt, History San Jose; Mary Roper, Inyo County clerk; Randy Weiche, Caltrans; Phil Pister, aquatics biologist; Bob Tanner, Red's Meadows Pack Station and a founder of Mule Days; Elizabeth Babcock and Harris Brokke, Maturango Museum, Ridgecrest, California; Jim Doherty, for his tales of the Buttermilks; John Louth, Bristlecone Pine Forest Manager; Pep and Nancy Partridge; Dave McCoy; Pete Korngiebel, Community Printing; Jill Kinmont Boothe and John Boothe; Gloria Chance; Cynthia Becht, Loyola Marymount University; Los Angeles Department of Water and Power; Rich Eyer; Dave Babb, columnist for the *Sierra Reader*; Karl, Cherie, and Anne Hartshorn; Theresa Stone, Paiute and Shoshone Cultural Center; Rebecca Bragdon, Tri-County Fair office; Bill Helmer, Big Pine Tribal Historic Preservation officer; Barbara Laughon, Mountain Light Gallery; Verna Mallory; and last but not least, the late Helen Partridge Milligan, Mom, for her stories of the valley.

Unless otherwise indicated, all photographs in this book are the possession of the Laws Railroad Museum and Historical Site and may not be used without permission. In addition, all photographs taken by Curtis Phillips, A. A. Forbes, Russ and Ann Johnson, Harry Mendenhall, or Burton Frasher are also owned by the Laws Museum. Many of the photographers are unknown.

INTRODUCTION

Bishop, California, legally became a city on May 6, 1903, and is still the only incorporated city in Inyo County. It has all the amenities of a miniature metropolis with three bakeries, a gourmet wine outlet, and three outstanding outdoor gear stores. There is even a mural society. Yet the coyotes still howl at night, and eagles and herons are common sights. Mountain lions and other large mammals are spotted at the edge of town. An audacious black bear recently ambled through Bishop; it was last seen heading south.

The history of Bishop sprang out of its distinct north-to-south geography. It is located between two mountain ranges—the White Mountains on the east and the Sierra Nevada to the west. Both spines have peaks that are over 14,000 feet, making Owens Valley the country's deepest valley. Bishop is at about 4,000 feet. The valley marks the beginning of the vast Basin and Range province, which extends eastward. Since it was formed between two earthquake faults, Owens Valley is considered geologically a graben.

This land gave the Native American people all they needed. The earliest inhabitants came perhaps before the last glacial period. They spent winters in the valley where they dug irrigation canals to water the native plants. These plants provided food and medicine and could also attract game. The people headed into the Sierra Nevada or White Mountains during the summer and fall when they collected their most important food, piñon nuts. In the biography of Viola Martinez, her Aunt Mary Ann tells her, "A long time ago all this land belonged to us, and we could leave our baskets and other things as long as we wanted and return to find them undisturbed."

The U.S. army moved into the valley in the 1860s and established Fort Independence about 40 miles south of Bishop. The aim was to make things safe for the settlers. These interlopers were involved in vicious valley clashes with local Paiutes and Shoshones at the time of the American Civil War. There were battles at Division Creek and Black Rock. The last major battle in the Owens Valley was the Battle of the Ditch of 1862, east of the present town of Bishop, but small skirmishes continued. Whenever the army came across Paiute food caches, the military would destroy the baskets of food. At Owens Lake, when over 30 Paiutes tried to swim away unarmed, they were killed. Over 200 Native Americans died during this time. Thus began what could be called the valley's first colonial era.

One of the early settlers was Samuel Addison Bishop, who came to the creek with his family in 1861. He named his San Frances Ranch for his wife, Frances Ella Young. The Bishops were only on this ranch about 18 months.

The town of Bishop was called Bishop Creek during its early settlement years, and the creek fanned out creating fertile meadows. During the 1860s, more and more settlers began homesteading the valley. These farmers had a ready market—the miners of Aurora and Bodie, 90 miles to the north. One of these 19th-century settlers was Mary Austin; and although she was not a farmer, she had a close relationship with the land, writing *Land of Little Rain*. This phrase stuck and is still used today when people describe the Owens Valley in the rain shadow of the Sierra Nevada.

There have been many old western movies filmed around Bishop. They always depict villains and dynamic plots. However, it was not the outlaws who were the important figures in the West, it was the hardworking, law-abiding residents who built the region brick by brick and fence post by fence post. Old-timers still talk about how verdant the Owens Valley was when crops and livestock were being raised for the Los Angeles market. This happened after the narrow gauge railway, the Carson-Colorado, was built from Carson City to Keeler to help the local mines. The depot for Bishop was at Laws and still stands today along with the Agents House and other added buildings at the Laws Railroad Museum and Historic Site.

The valley's growing agricultural community thrived until the Los Angeles Department of Water and Power decided the south sloping valley would be perfect for a gravity-driven aqueduct. Thus began another conflict and a second colonial phase. Some would say that the European Americans had it coming except the local Paiutes lost jobs during this time as well. By its own estimates in the 1930s, the City of Los Angeles owned 95 percent of the agricultural land in the valley. Many Farmers sold their land to Los Angeles and moved to Oregon, the Central Valley, or, ironically, Los Angeles. Since the merchants were losing farming customers, a local depression ensued and Los Angeles was forced into paying reparations to both white merchants and Native Americans who had lost jobs. Today some of the old farm sites can be located by finding the silos and groves of cottonwoods dotting the landscape. However, there are still several ranches in existence in both the Owens Valley and Round Valley. Most of them are leased from the City of Los Angeles. In 1920, there were 25,453 head of cattle on Inyo County ranches; and in the 2007 California State Agricultural Census, there were 14,253 head. Contrary to other claims, Los Angeles only owns 3.9 percent of Inyo County land, while the federal government owns 92 percent. The City of Los Angeles is trying to be a better partner with the valley. The Los Angeles Department of Water and Power recently began to run water in the lower Owens River for the first time in decades.

Whereas the economy had been based on agriculture and mining in the 19th century, tourism was the future. Highway 395 was paved to Los Angeles in the late 1920s. Airports were built. Trails into the backcountry were dug and blasted from rock walls. Outdoor sports became the hallmark of the Eastside economy. In Bishop, Mule Days was added in 1969, and it has since become a huge tourist attraction. Finding lodging during this Memorial Day weekend festival can be difficult.

Highway 395 continues to be a national north-south connector. According to Caltrans estimates, over 15,000 vehicles a day travel on Bishop's Main Street; 930 of these are classified as trucks. Although a bypass has been discussed since the 1920s, Main Street still thrives with services for local people and tourists. The telephone book lists 20 motels and several inns. Topics of conversation do not change much. Water is still an issue as is moving part of the county services in Independence to Bishop. In 1908, however, the controversy was moving the county seat to Big Pine at a cost of $60,000. Such ideas are still reported in the *Inyo Register* much as they were over a century ago.

This book is not a complete history of Bishop. The information was generated by whatever high-quality photographs were available at the Laws Railroad Museum and Historical Site archives and through contributions.

One

DEEPEST VALLEY

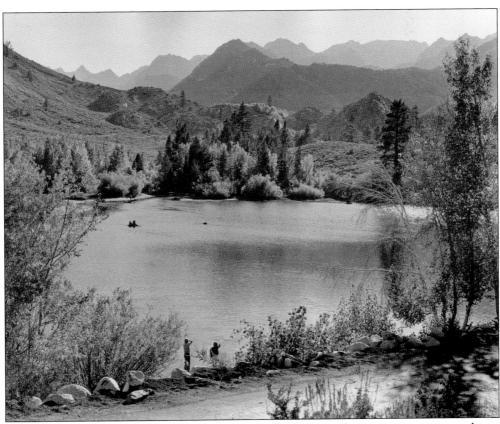

In the early years, Bishop was a ranching and mining hub. As the economy transitioned into tourism, it was the natural landscape that became the primary asset for Bishop and attracted people to the town and its unique environs. Intake II on Bishop Creek is a location for hiking, fishing, or viewing the fall colors.

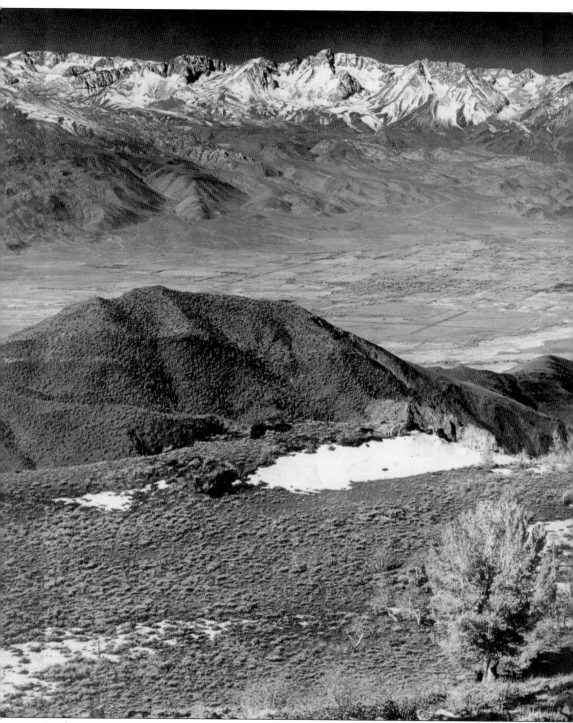

Looking west from the White Mountains atop Silver Canyon, Bishop can be seen south of the Owens River. To the west of Bishop is the Sierra Nevada with Mt. Tom prominent. Owens Valley is a graben, with earthquake faults at the base of each mountain range. This became apparent in 1872 when one of California's largest earthquakes hit the valley's west side, shaking buildings to

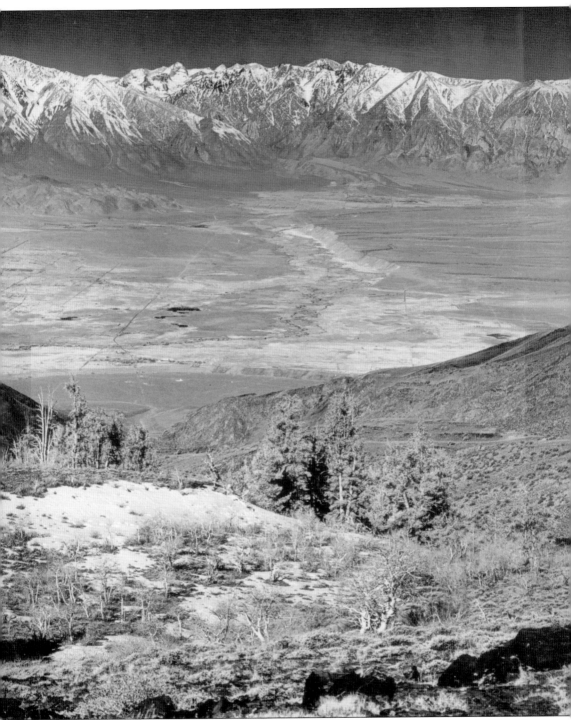

their foundations—especially in Lone Pine. The Owens Valley is the deepest valley in the United States with the valley floor a high desert. Writer Mary Austin, in the *Land of Little Rain*, called the valley, "a big mysterious land, a lonely, inhospitable land, beautiful, terrible." It has, however, become a land for outdoorsmen, whether they are ranchers or rock climbers. (Curt Phillips.)

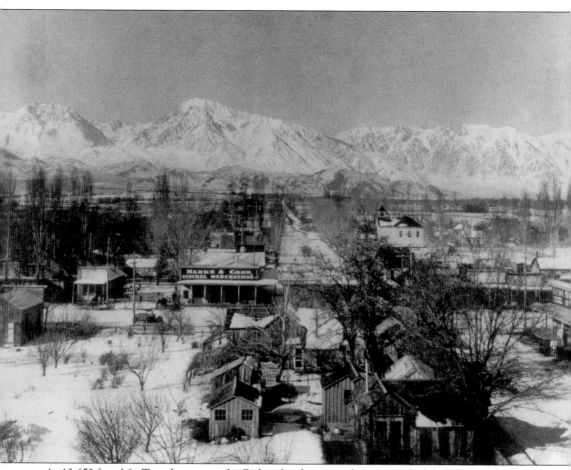

At 13,652 feet, Mt. Tom dominates the Bishop landscape and was named after Tom Clark. Clark's family had homesteaded all the land in Bishop north of Line Street. Native American friends guided the younger Tom to the top of the mountain for the first known European American's ascent in the 1860s. The Paiutes called the mountain Ow-wah-ne. Most cultures have a flood myth, and the Paiutes are no exception. Instead of a dove, however, it is the little helldiver that finds land; and the land above the waters is not Mt. Ararat but Mt. Tom. The Owens River and numerous Sierra creeks feed the Owens Valley. Bishop Creek in particular forms a delta of many small streams, and Bishop Cone was once very green with meadows. The Paiutes dug six canals to irrigate native plants and attract game. This 1902 image looks west on Line Street. Basin Mountain can be seen to the south of Mt. Tom and Wheeler Ridge to the north.

Joseph Inman started a dairy in the Buttermilks in the 1870s. The sawmill nearby was owned by Tim Lewis, and mill workers and teamsters would stop at the dairy for a drink of buttermilk. Inman's son, Joe Jr., went on to become a Republican state senator in 1916. He was also director of the California Oriental Exclusion League. The Buttermilks are a spectacular frontage to the Sierra, and pioneering climber Smoke Blanchard put the area on the map as the Bouldering Mecca of the West. Along its streams, the rocks are also a birders' paradise. Adjoining the range of boulders to the north are the Tungsten Hills, which are pitted with old mines. These two areas have plenty of bitterbrush, the mule deer's favorite food. The deer winter in this area; therefore, so do the mountain lions. (Both, Curt Phillips.)

In Round Valley and on the west side of the Owens Valley, the earth is fairly rich from the sierra alluvial and granitic soils. Farmers need only add water and manure, the rancher's favorite fertilizer. This early image shows a crop growing, possibly potatoes. Irrigation and water rights are still hot topics. And Inyo-ites still pride themselves on their vegetable gardens.

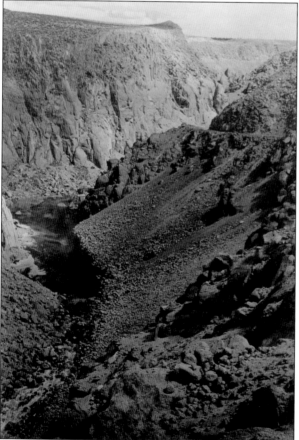

Northwest of Bishop lies 10-mile-long Owens River Gorge, cutting through volcanic tuff. At the northern end is the Long Valley Dam at Crowley Lake. At the other end is the Pleasant Valley Dam and Reservoir, which is favored by waterfowl. On any given day in the gorge, a person might see rock climbers, fishermen, and hikers. The Los Angeles Department of Water and Power restored water to the gorge in 1991.

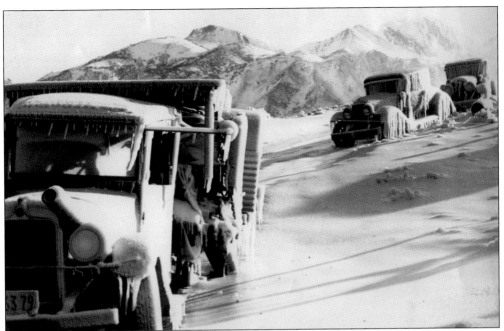

Bishop does not always get great amounts of snow because it is in the rain shadow of the massive Sierra Nevada. However, the mountains often have vast snowfalls since they are close to the Pacific Ocean and in the path of the prevailing westerlies. Parts of the Sierra have recorded some of the heaviest snowfalls anywhere, most dramatically with the infamous Donner Party. These conditions make Bishop a staging area for winter sports. Whenever there is a big snowfall in Bishop, old-timers always say, "Heck, you should have seen the snow in 1933!" Starting January 11 of that year, snow fell off and on for the rest of the month, and 56 inches of snow accumulated on Main Street. It is from spring runoff that the Owens River swells and flows to Owens Lake and ultimately Los Angeles.

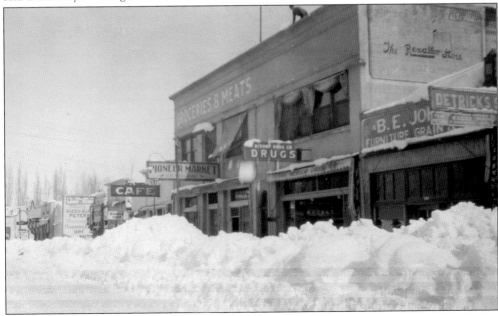

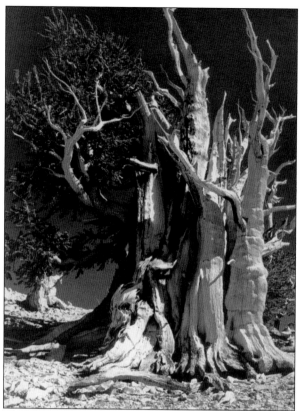

The Great Basin bristlecone (*Pinus longaeva*) grows at high elevations in the intermountain ranges of the Great Basin. The oldest of these trees are located in the White Mountains directly east of Bishop and are considered to be the most ancient trees on earth, the oldest more that 4,800 years old. Since bristlecones live in a narrow band just below the tree line, between 10,000 and 11,000 feet in elevation, the growing season is extremely short. These ancients are slow growing, producing dense and resinous wood resistant to disease and pest infestation. The winds blow sand and ice, twisting and sculpting the trees into magnificent shapes (left). The Schulman Grove was named after Dr. Edmund Schulman who dated the ancient trees and declared them to be the oldest. He can be seen below studying the bristlecone pine tree rings. (Left, Curt Phillips.)

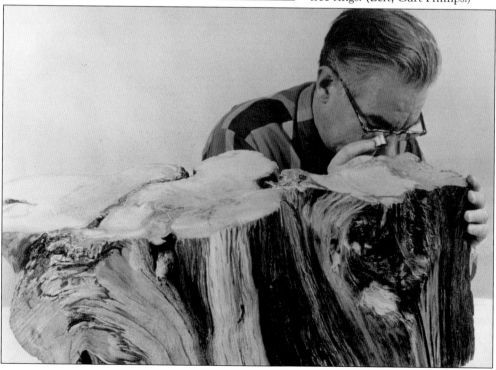

Two

THE STORY BEGINS

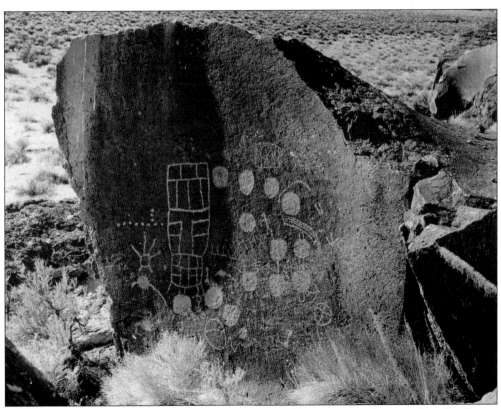

According to archaeologists, there have been humans (the Paiute word is *numu*) in the Owens Valley at least since the last glacial period and probably before that. Over the years, the valley has disclosed much evidence of this in the form of rock art, grinding stones, house foundations, and arrowheads. It is now against federal regulations to disturb, desecrate, or remove any of these items, and most are considered Native American sacred sites. (Curt Phillips.)

There are over 100 rock art sites near Bishop, and each spot has its own style. The ages of art and artifacts at these locations have a wide range. Some sites are at least 200 years old, while others could go back as far as 12,000 years. People are generally depicted with a front view, animals from the side, and reptiles from above. There are several theories as to the meanings of the various glyphs. Perhaps they were a way of visualizing a hunt or were religious symbols. They might lay claim to an area. A major question is not just each glyph's meaning but what the whole site means. It is fairly common in the region to come across grinding stones and other ancient artifacts. (Left, Pam Vaughan.)

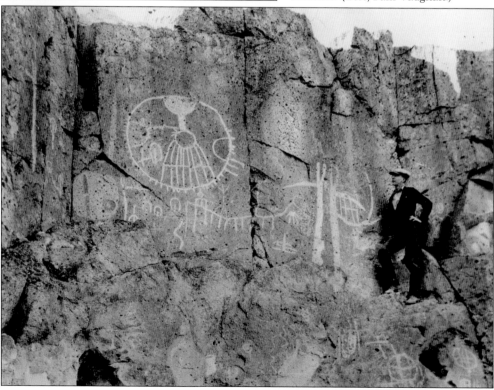

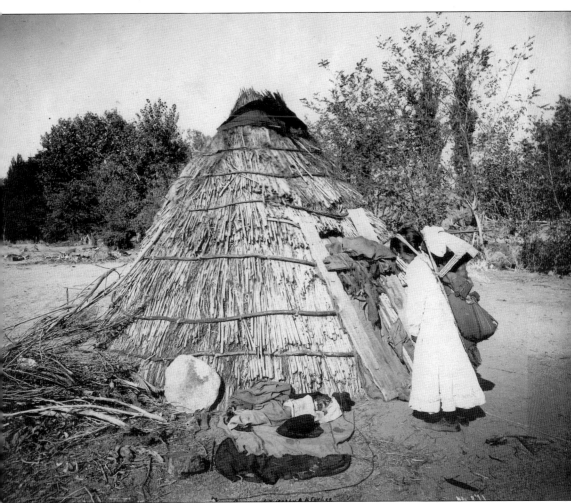

A Paiute family's word for home was a *to-ne*, which white people called a wickiup. The Paiutes seasonally shifted their campsites and lived in small groups near water and wood, where the *to-ne* was built of tules. The tules were bundled and then bound into circular walls several inches thick. The materials were readily available and weather resistant. The doorway faced east. In the center there was a cooking fire, and the smoke went through a hole in the roof. The inside walls and floors were lined with leaves or grass. The door was small, which helped insulate the dwelling. The woman pictured here is carrying a baby in its cradle board. One family would live in a *to-ne*, often with the grandparents.

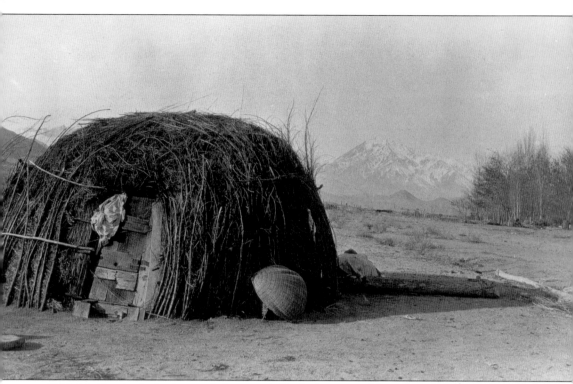

With Mt. Tom in the background, this is probably the location of the original Sunland Reservation south of town. The destitution of the Paiute became increasingly apparent. In 1912, a 67,164-acre reservation was proposed on the volcanic tablelands north of Bishop. In 1930, Los Angeles suggested possibly relocating the Paiutes out of the Owens Valley altogether. In an act of Congress passed March 10, 1937, reservations in Bishop, Big Pine, and Lone Pine were set aside; Bishop has 875 acres presently. Each small Paiute or Shoshone family was allotted 2.5 acres, with larger families obtaining 5 acres. In 1939, E. K. Burlew, acting secretary of the interior, and mayor Frank L. Shaw of Los Angeles signed the overall deed.

In the image to the right by Harry Mendenhall, a Paiute man is standing with a bow and arrow amidst a basket collection. Willow, the primary material used in local baskets, was gathered during the winter, debarked, and the knots smoothed out with an obsidian knife. Then the willow pieces were split into thin strips. The original baskets did not have much ornamentation; the complex patterns seen later were to make them more appealing to white collectors. The dark colors were from willow bark and devils claw and the red from yucca. Some of the more elaborate baskets took about a month to make. The shallow baskets were for winnowing, which separated the chaff from the seeds. The baby cradle boards on the wall (below) are called *hu-va* or *he-u-ba*.

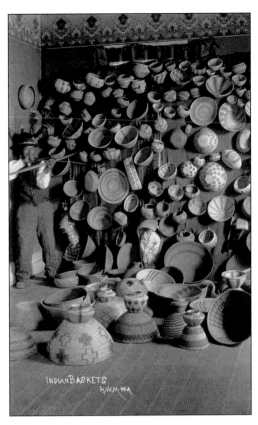

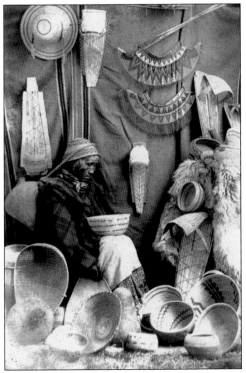

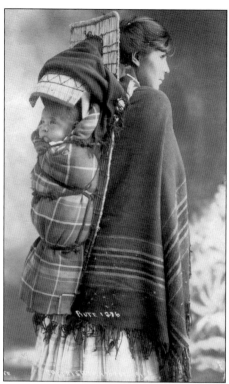

A young Paiute woman is shown before 1910 with her swaddled baby in its willow wicker cradleboard (*huva* or *heuba*.) The hood acts as a sun visor, and the linked pattern design indicates this is a baby girl. Boy babies had separate design elements. Animal hides could be used on the cradleboards in the winter or where the climate was colder. Shells and beads were sometimes added.

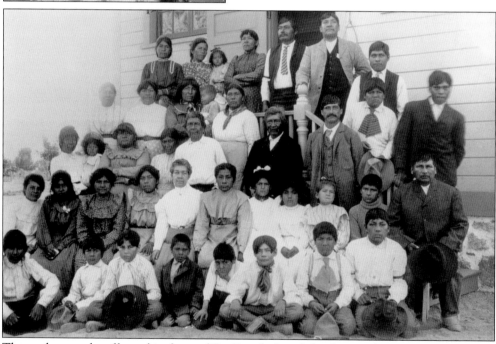

The students and staff stand in front of Big Pine Indian School around 1900. This institution was featured in a famous California State Supreme Court case, *Piper v. Big Pine*. In 1924, a Native American girl, Alice Piper, wanted to attend Big Pine High School. The court ruled in her favor. It was a forerunner to *Brown v. Board of Education* 30 years later.

Three

EARLY SETTLERS

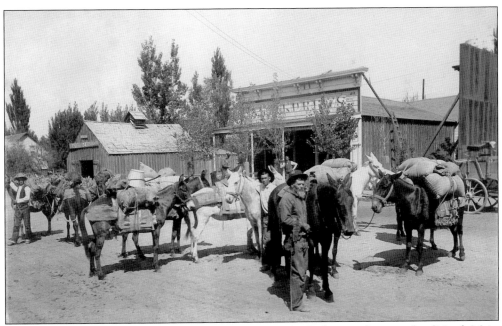

Melinda's Pack Train stands near Frank Andrews's store in Bishop on the eastside of North Main Street in the early 1880's. To the left is Dutch John's Blacksmithing and Wagon shop. Mule trains were the earliest form of transporting goods into the Sierra above Bishop due to rugged terrain. Andrews went on to become a founding member of the Bishop Chamber of Commerce.

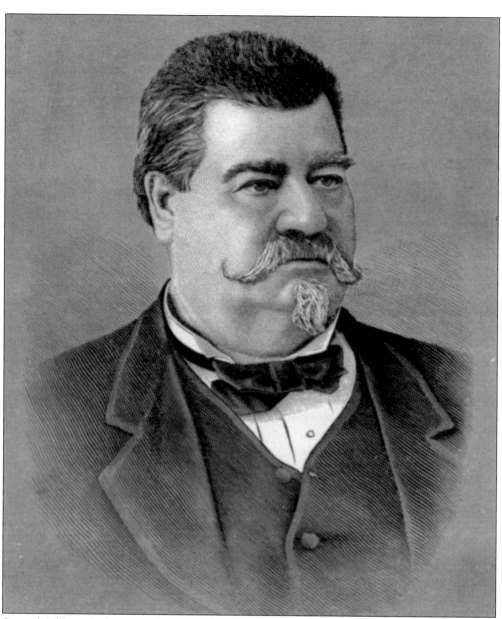

Samuel Addison Bishop was a Virginia adventurer who came west seeking gold. He later became an army Indian fighter. A restless man weighing over 300 pounds, Bishop then worked at Fort Tejon where Captain Gardiner said in a letter about him preserved by the Ridge Route Museum, "I have here a Justice of the Peace on my hands. . . . and he, the Justice, is now preparing himself by reading a thick volume of California laws. His appearance is not very judicial. He is in his shirt sleeves, with a hat considerably the worse for wear, a huge pair of Mexican spurs, with buckskin leggings, and of course, what no Californian travels without, a revolver in his belt." Bishop drove over 500 cattle into the Owens Valley in 1861 and founded the San Frances Ranch on Bishop Creek near Red Hill in order to provide food for the Aurora Mining District. After leaving the Owens Valley, the Bishops moved to San Jose, where Samuel became an influential banker and founder of the streetcar system. (History San Jose.)

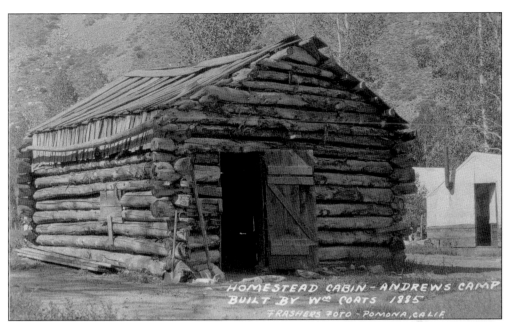

HOMESTEAD CABIN - ANDREWS CAMP
BUILT BY Wm COATS 1885
FRASHERS FOTO - POMONA, CALIF.

In 1885, William Coats homesteaded and farmed on the south fork of Bishop Creek. No longer standing, his cabin was located at Coats Meadow north of the present Bishop Creek Lodge. Andrews Camp, the first resort in this area, was later located on this site. (Burton Frasher.)

Ada Hightower was one of the first Anglo babies born in Inyo and Mono counties; this was before 1870. Her father was sheriff George Hightower, whose posse cornered escaped felons at Convict Lake in 1871 after they escaped from the penitentiary in Carson City. In 1885, Ada married Amos Buck, who opened Macks Sawmill, where he subsequently died accidentally in 1887, leaving her to raise an infant son.

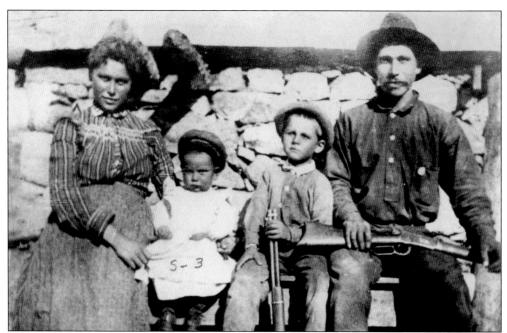

From left to right, Annie Spratt, Caeser Giraud, Lewis Hamilton, and James Willis Spratt pose for this image that depicts the stoicism of early life in the Owens Valley. Annie was the daughter of John Spratt, the stagecoach robber. Her second husband was "Little Pete" Giraud, made famous in the Mary Austin books. Her third husband was Paul Zucco. (Russ and Ann Johnson Collection.)

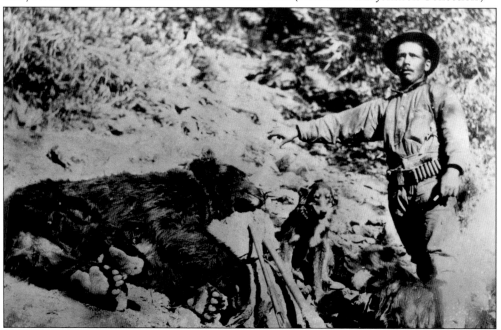

Pierre Joseph Giraud is shown with his two dogs at Monache Meadows near Lone Pine, where he has just snagged a bear in 1895. Pierre was better known as "Little Pete" and was from a well-known Bishop sheepherding family. Hunting is still a common recreational activity in the Eastern Sierra today. (Russ and Ann Johnson Collection.)

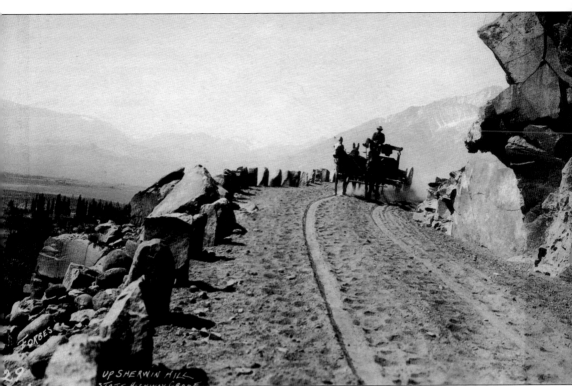

Highway 395 leaves the Owens Valley at Jackass Mesa on Sherwin Grade. Its predecessor was the Sherwin Hill Wagon Road shown here about 1900. This route was named after James L. C. and Nancy Sherwin, who were some of the earliest settlers of Round Valley on what would become Jess Chance's ranch. Sherwin was going to become a doctor in his native Ohio when gold was discovered in the California Mother Lode. He came by ship to California and soon was doing so well at the mines that others called him Lucky Jim. He and Nancy later lived in Virginia City, where he went into the lumber business, and later in Opher City, Nevada, and Benton, California, where he was a miner. He and Nancy and their children then homesteaded in Round Valley, where Jim built the road over Sherwin Hill to his two sawmills—one on Rock Creek and the other at Mammoth. It was originally a private toll road where Sherwin charged $1 for a horse and buggy or 25¢ for a horseman. Other toll roads included Westgard Pass.

Rosa Rossi poses with her son, Benedetta, around the time they came to the Owens Valley from Italy in the 1880s. She and the Rossi patriarch, Angelo, brought several children to the valley. There are hundreds of their descendents in the United States. In the valley, the Rossis were shepherds, stonemasons, ranchers, and miners. Rossi Hill, 3 miles south of Bishop, is named after them.

Round Valley residents gathered in 1895. They are, from left to right, (first row) Kate Arcularius Watterson, Janie McBride, Nettie Bulpitt, John Shipley, and a Mr. Blaisdell; (second row) a Mr. Vaughan, William Bulpitt, Carrie Arcularius Evans, and three unidentified. The Arcularius Ranch still exists in Round Valley and is operated by descendent Howard Arcularius and his wife, Linda, an Inyo County supervisor.

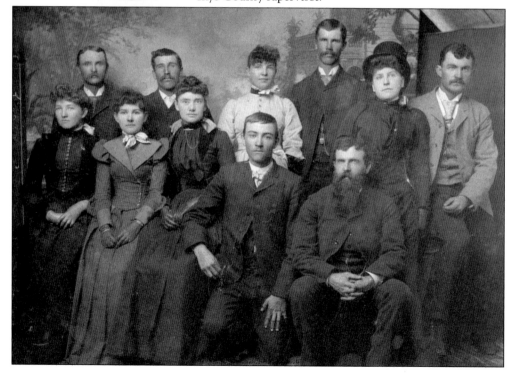

Four

A Sense of Community

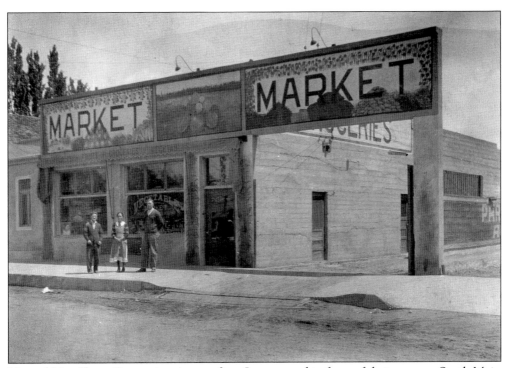

Mr. and Mrs. Shozo Otome, immigrants from Japan, stand in front of their store on South Main Street. The 1880 Census for Bishop Creek listed people from 27 different countries and territories and 39 states. Independence has a Jewish cemetery and possibly a Chinese cemetery. Manzanar has a Japanese cemetery from the internment camp that was located there during World War II.

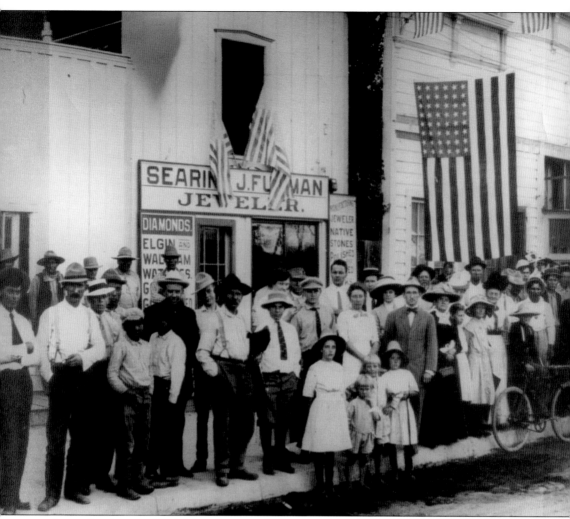

A crowd gathers on South Main Street in 1910 to pose during the Inyo Good Road Club opening of the El Camino Sierra, present-day U.S. Highway 395. This image is part of a 360-degree photograph. The people are multiethnic and are standing in front of Searing J. Fuhrman's jewelry store. Fuhrman was Jewish. The purpose of the El Camino road series was to promote automobile travel, and the Inyo Good Road Club was formed for the promotion of this Eastern Sierra highway. In addition to the Sierra route that connected Lake Tahoe to Los Angeles, there were three others—the El Camino Real connecting San Francisco to San Diego; El Camino Capital linking Oakland, Antioch, Sacramento, and Lake Tahoe primarily along present Highway 50; and El Camino San Diego joining Pasadena, Riverside, Temecula, and San Diego. The president of the local club was Dr. Guy P. Doyle, and vice president was Mark Watterson.

The old church for the Paiutes was on Carpenter Lane in the Sunland District (below). Viola Martinez in her biography said that Christianity paralleled the Paiute view of "the idea of loving one another, of being helpful, taking care of one another. I remember my Uncle Bob saying, 'We don't have insurance policies. We take care of one another.' . . . The Paiutes had a deep faith." The Valley Presbyterian Church now serves some members of the tribe. One of its ministers was Rev. Sidney Bird (right). (Right, Curt Phillips; below, A.A. Forbes.)

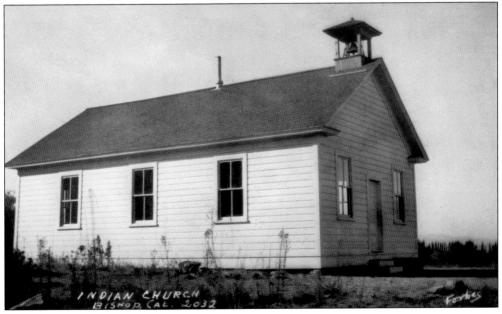

The Harvest Festival began in November 1911 as a forerunner to the Labor Day weekend Tri-County Fair and Homecoming Celebration. Parade floats were very elaborate, and each district had an entry. There were competitions for produce, livestock, and needlecraft. There was a baby beauty contest—one prize going to the prettiest baby and another for the sturdiest baby. The festival's novel attraction was the Alfalfa Palace made of bales of alfalfa and located at the rear of Fred Bulpitt's store, where Joseph's market is today. This forerunner of today's straw bale structures contained agricultural exhibits. The driving force behind this festival was William C. Parcher. Other directors of this rural shindig included such names as G. Simeral, A. Marshall, M. Q. Watterson, G. H. Dusenberg, Les Horton, J. W. Bernard, C. A. Curtis, J. L. Gish, G. L. Furley, and Bertrand Rhine. (Below, A. A. Forbes.)

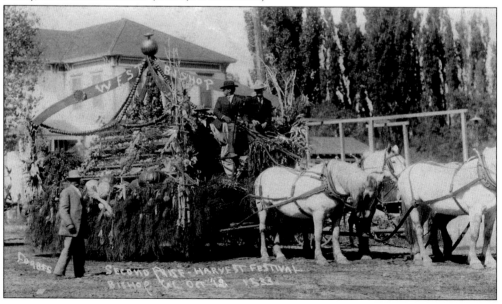

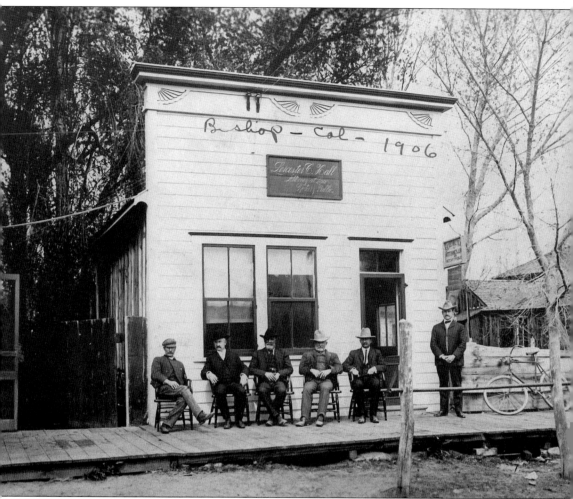

L. C. Hall (left) sits with Charles Summers, Charles Meddison, A. O. Collins, and others in front of his law office on Main Street on April 16, 1906. Hall was the uncle of Ernest Hemingway and was an important figure in the water dispute with Los Angeles. After his wife, Nevada Belle (Butler), passed away from the flu pandemic in 1918, some folks say he became bitter. In the conflict, he sided with a group of ranchers who wanted to sell to the City of Los Angeles. His July 1950 *Los Angeles Times* obituary is titled "Attorney Dies 26 Years After Being Hanged." This referred to a group of Bishop citizens and ranchers who took him out of town and strung him up to a tree. When he gave the Masonic distress signal, they cut him down and revived him. He refused to reveal their names in a grand jury investigation and subsequently moved to Glendale.

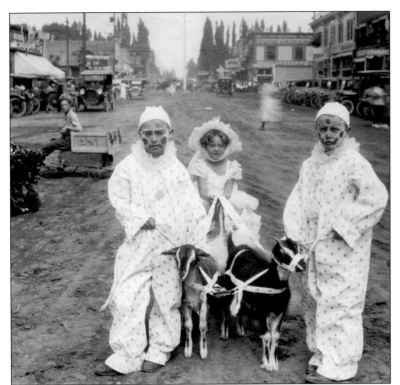

Looking north on Main Street, children are getting ready for a fair parade, the boys dressed as Pierrots. It is the early 1920s, before the road is paved. In the distance, there is a flagpole in the middle of the intersection of Main and Line Streets. The pole's location, indeed its very existence, is something old-timers enjoy debating.

These children are dressed in their Sunday best while posing for this shot. They got one new dressy outfit for Easter and went through an average of two pairs of shoes a year. If they wore out the soles of their shoes before time for a new pair, they put chunks of newspapers inside. In Bishop, country kids went barefoot most of the summer.

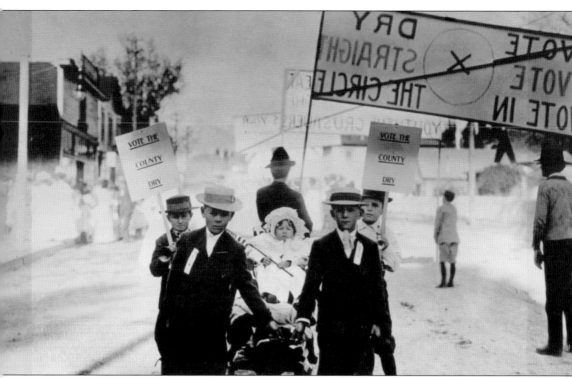

In April 1910, a demonstration was held the morning of the election to decree Bishop a dry city. The women and children demonstrated while the men stood in the background. The ordinance passed overwhelmingly as the *Inyo Register* headlined, " Bishop Votes out the Saloon." In 1874, Bishop residents had also voted themselves dry, but the California State Supreme Court overturned the ordinance. The movement in 1910 was spearheaded by the national Anti-Saloon League. It was further cemented by the voters electing a complete anti-liquor slate of candidates. There were several local court cases involving liquor during 1911, which included the case of John Shuey and two others who were accused of giving alcohol to others; the outcome was a hung jury. During the Prohibition era, bootleggers were common in Bishop, which often resulted in the incarceration of residents caught with the demon drink. In one such raid in 1923, eight Bishop residents were taken into custody. The contraband liquor in question flowed down Line Street after being dumped there by authorities.

The young Baptist minister Rev. Andrew Clark started the first church congregation in Bishop in the 1860s. Charter members included Ross May, W. D. Clair, W. P. Teel, Henrietta Deck, W. C. Driver, and Ada Taylor. It was considered a mission in this backwater outpost. Their church structure was built in 1907 but no longer stands. Reverend Clark gave the town the property on which Bishop Grammar School stood.

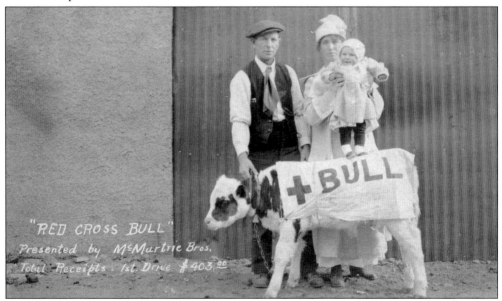

The McMurtries use a calf as a "Red Cross Bull," where they raised over $400. Bishop folk frequently had Red Cross drives in a time before the counties had organized welfare departments. In each district, the county supervisor oversaw welfare cases, sending the ailing poor to Los Angeles for treatment. Elderly folks in need went to the Big Pine "Poor Farm" where they could raise their own food.

Bishop Volunteer Fire Department has long been considered one of the top-ranked volunteer fire departments in California. It was organized before 1903. The rural fire district surrounding Bishop was founded in 1947. Bishop volunteers are seen putting out a fire at Colonial Rooms Inn on Academy Street in the 1950s (right). This structure was originally a Bulpitt family home. At the top of the ladder is Larry Huffman. The photograph below shows firemen in October 1915 at the Harvest Festival. In 2009, a new training center was completed on East Line Street that includes a state-of-the-art fire tower. For many years, the volunteers have sponsored both the Destruction Derby at the fair and also the Fourth of July fireworks display at the Bishop Airport.

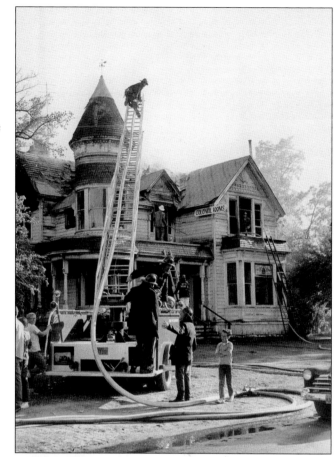

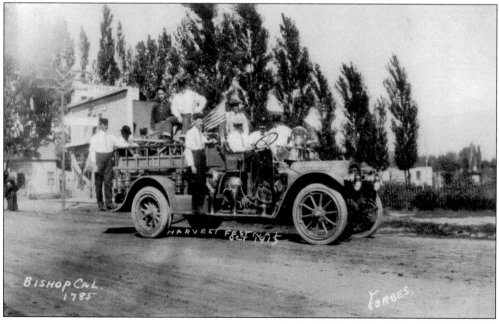

Looking southwest, Bishop Grammar School sits in a semirural setting before the roads were paved. In the distance is the Coyote Front. Poplar trees are prevalent in this picture and are still planted in the Owens Valley today as windbreaks.

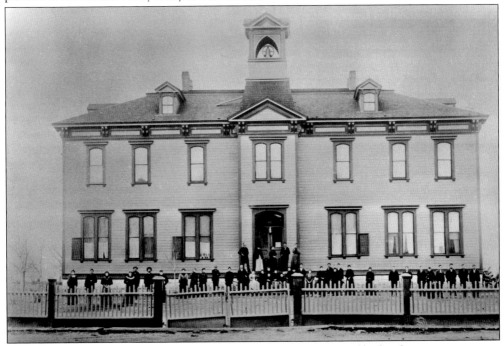

Inyo Academy, founded in the early 1880s, was the first institute of higher learning in eastern California. It was located just behind the site of the main building of the current Bishop High School. Eight teachers instructed such useful subjects as Greek, Latin, French, elocution, penmanship and drawing, music, and the usual history, English, and math. Tuition was $10 per term.

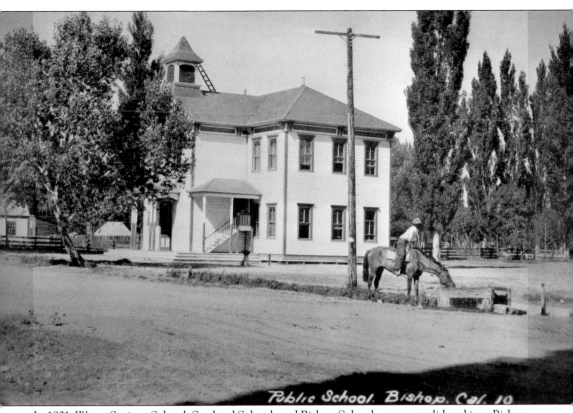

Public School. Bishop. Cal. 10.

In 1921, Warm Springs School, Sunland School, and Bishop School were consolidated into Bishop Union Grammar School. Bishop Grammar School was constructed in 1890 and used as a school until 1914, when the entire building was moved to where the Bishop Police Department is today. The building was used for the library, city hall, and fire station until it was torn down in 1950. In 1891, the district reported that the school year was composed of 140 days as compared to today's 180. Bishop schools had an overall enrollment of 134 with an average daily attendance of 87.5. In 1891, it was common for students to attend only through the eighth grade. It was not until 2009 that the Bishop Union High School District and the elementary schools were unified.

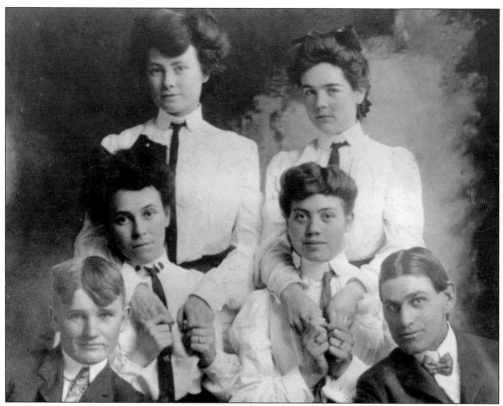

In 1905, Bishop Union High School (BUHS) produced its first graduating class. Members of the class are, from left to right, (first row) Claude Teel and Gus Cashbaugh; (second row) Estelle Jones and Alice Dunlap; (third row) Hazel Gunter and Kate Bigelow. Cashbaugh went on to record much of early Bishop history for the Laws Museum archives and lived to be over 100.

Jack Alexander (left) and Dan McCarthy, two handsome seniors, look dashing for Old Clothes Day at Bishop Union High School in 1936. Since graduating classes were small in those days, students knew everyone on campus. Listed in *El Piñon*, the yearbook, the class of 1936 had 33 students; the class of 2008 had 211. (Helen "Chick" Partridge Milligan.)

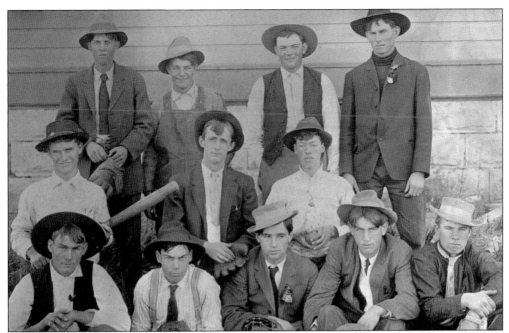

Bishop has had a long love affair with baseball and softball. Even today, hundreds of local adults and children play in leagues. Here is an early team about 1916. They are, from left to right, (first row) John Yandell, Fred Callsey, John MacIver, Bud Scheld, and Walter Gish; (second row) Walter Banta, Lester Albright, and Lester Gorman; (third row) Ed Farrington, Otto Wise, George Bigelow, and Lunsford Yandell.

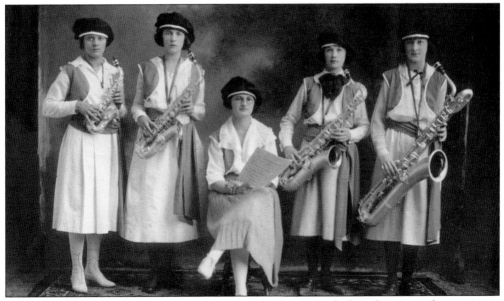

A Bishop Union High School girls saxophone quartet poses with their director and instruments in the 1920s; their names are unknown. They may have gotten their saxophones from the music store in town or from the Sears and Roebuck catalog. The catalog started in the 1880s and carried everything from musical instruments to shotguns. In its 1936 selections, Sears sold saxophones for $50.

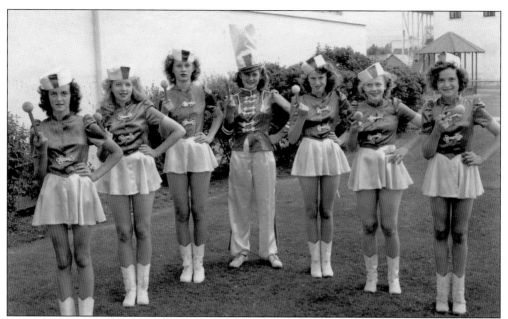

Baton twirlers stand at attention at Bishop Grammar School in 1943. They are, from left to right, Pat Talbot, Arlene Holland, Shirley Goodwin, Janice Kixmiller, Orpha Holt, Martha Boore, and Phyllis Carr. Pep squads are still popular in Bishop in the form of cheerleaders, flags, and drill teams. They can be seen at the local games and parades.

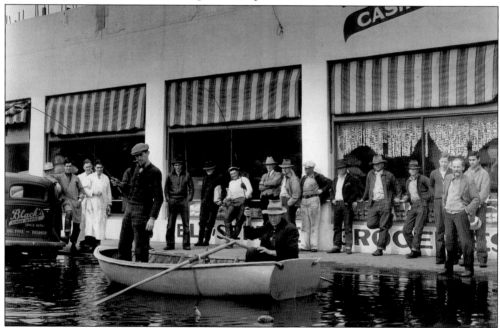

In the years before towns engineered drainage systems, flooding was common. In 1926, the intersection of Main and Line Streets was immersed. In the Land of Little Rain, downpours are often reason enough for amusement. Engaging in fishing pranks are Don Dean, Cap Aubrey, Bob Pellisier, Baldy Farrington, Carl McKellips, Claude Ford, Pop Craig, George Brown, Julien Romero, and a Mr. Provience. The rest of the men are unidentified. (Curt Phillips.)

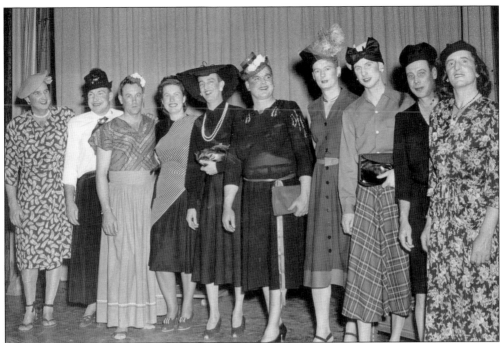

Cross dressers in Bishop? These "gals" are having a good time entertaining at a Bishop Parent-Teacher Association meeting in 1947. In the image are, from left to right, Curt Phillips (who took many of the photographs in this book,) Bob Bates, Wilton Cornell, Sybill Rogers, unidentified, Leo Castagno, two unidentified, Howard Wentworth, and Mannie Olds.

Pioneers who came to the Owens Valley usually had many children. Their descendents often married into other pioneer families and today are numerous. Many of the people from these old families in Bishop are related. Here the large Douglas Joseph clan attends a wedding in the 1940s. Joseph's market was owned by Douglas Joseph (first row, third from right).

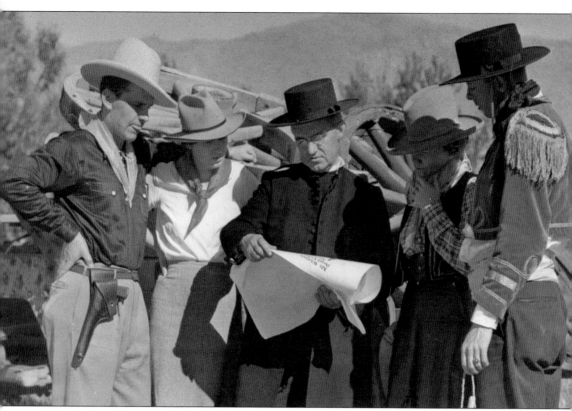

The Rt. Rev. Monsignor John J. Crowley was known simply as Father Crowley. Curley Fletcher, the great cowboy poet, dubbed him "Shepherd of the Sage." Crowley Lake was named after him, as was Father Crowley Point in Death Valley. The "Desert Padre" served Bishop and all of Inyo County as far away as Death Valley. He was born in Killarney, Ireland, to a family whose children mostly became priests and nuns. When the family lost everything in a lawsuit, they immigrated to the East Coast of the United States. Once he became a priest, he was assigned to California and eventually the Owens Valley, where he helped to pull the valley out of the Great Depression by organizing civic groups, building the economy—especially the tourist industry, and tending to people even if they were not Catholic. Crowley had a quick wit and was a great storyteller. He is pictured here at the Wedding of the Waters celebration.

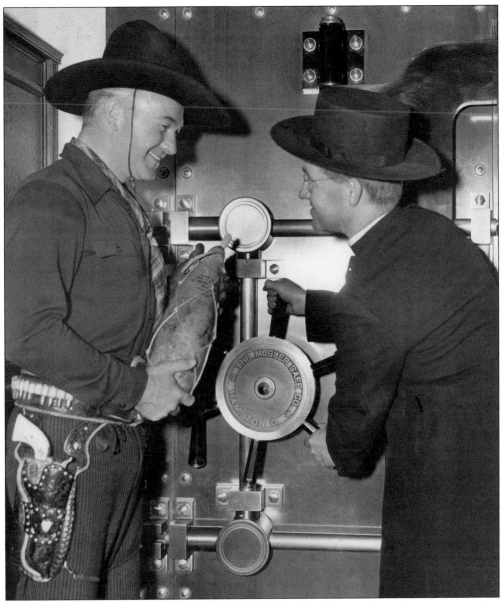

In October 1937, Father Crowley organized the Wedding of the Waters, a three-day pageant opening the Lone Pine–Death Valley Road. For one of the biggest pageants in California history, the kickoff was the pressing of a telegraph key by Pres. Franklin Roosevelt. The California governor attended the event. Washoe Native American Jerry Emm ran from the summit of Mt. Whitney (then the tallest spot in the United States at 14,495 feet) to the highest lake in elevation, Lake Tuleinyo, and collected water in a gourd. He ran it down the trail to a Pony Express rider who delivered it to Lone Pine, where movie star William Boyd, pictured here, placed it in a vault. The next day, prospector Sam Ball put the gourd on his burro, taking the water to a covered wagon pulled by oxen. This was followed by a 20-mule team, stagecoach, train, and Lincoln Zephyr. Finally folks in an airplane dumped the water at Death Valley's Badwater, the lowest elevation in the United States, at 282 feet below sea level. Both geographic points are located in Inyo County. (Maturango Museum.)

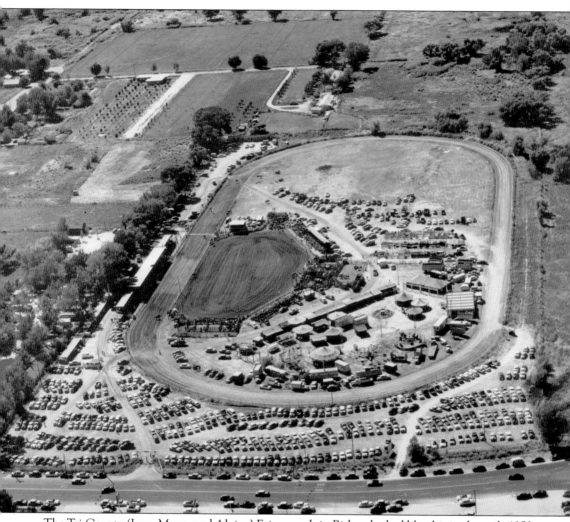

The Tri-County (Inyo, Mono, and Alpine) Fairgrounds in Bishop looked like this in the early 1950s during Labor Day Homecoming weekend. The racetrack is not used for racing much anymore, but for several years, there were pari-mutuel mule races during Mule Days on this track. Fairs in Inyo County have occurred irregularly over the years due to lack of funding from the State of California. The first Tri-County Fair took place October 10, 1887, in Independence. Prizes ranged from a lady's fan and breast pin to $100 for winning the running and trotting race. The fair gave way to the Harvest Festival in 1911. In 1934, the Bishop Homecoming and Labor Day Association was formed. Besides Mule Days, this locale hosts such events as the fair, the Choo-Choo Swap Meet, a home show, the California State High School Rodeo, and various other activities. (Gloria Chance; photograph by Bob Symons.)

Five

BISHOP FOLK

With a backdrop of Mt. Tom, cowboys pose on the Jess Chance Ranch in Round Valley. Included in this picture are Jess Chance, Gerry Chance, Jess Chance Jr., Orville Houghton, and Lloyd Phillips. Although the Bishop region has interests that are evolving past the ranch culture, images and stories of the Old West rekindle the romantic notion of the cowboy way of life. (Gloria Chance.)

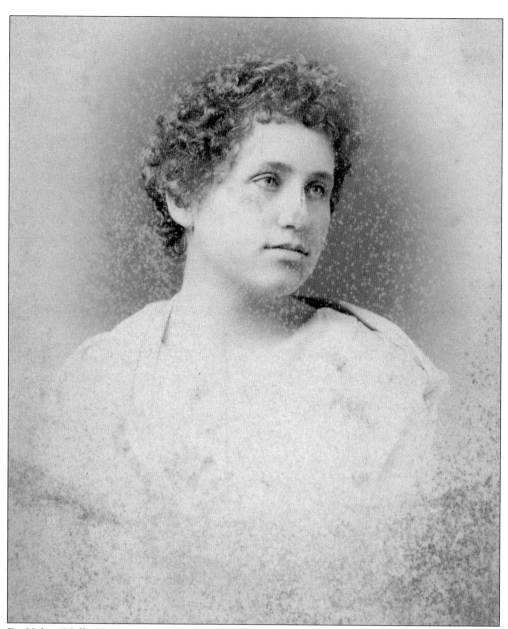

Dr. Helen "Nellie" McKnight Doyle was an early female physician graduating from the University of California San Francisco in 1894 when there were only two other women in the class. Her life started out in rough conditions in the East. Her father, Smith MacKnight, had gold fever, so he came west and mined in the Eastern Sierra. Nellie and her mom lived in New York with the grandmother, who subsequently died of typhoid. Nellie's mom went to work in a corset factory and later committed suicide. Little Nellie then lived with an uncle and abusive aunt before being taken by kindly friends to the Dakotas, where Nellie survived a prairie fire and a tornado. When she was a teenager, her father finally sent for her, and they moved to Bishop where he was a surveyor. He insisted she go to medical school even though she wanted to be a writer. Nellie found she liked medicine. When she married Dr. Guy Doyle, she practiced medicine in north Bishop, and he practiced in south Bishop. Her autobiography, *Dr. Nellie*, became a best seller.

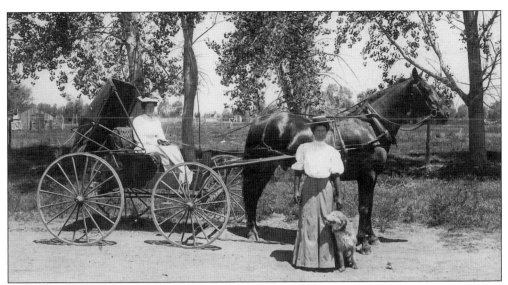

Mary Belle (left) and Lema Killian are shown above with their dog and carriage after arriving in Bishop in 1898. Mary Belle married William McCrosky, a local harness maker, and Lema married Louis Bodle, who became county auditor in 1931. Mary Belle worked on local elections, and the McCroskys homesteaded a ranch northwest of the present airport. At one time, Four Corners was called McCrosky Corners. Fraternal organizations were prevalent in the Owens Valley, and Lema was worthy matron of Eastern Star and a member of the Rebekahs. In 1935, the Bodles were badly bruised when their automobile flipped over south of Bishop. Lema passed away in 1971. Identified in the photograph below are, from left to right, ? Summers, Elizabeth Hart Summers, Will McCrosky, Margie Shaw Kewly, Dora Shaw (seated), unidentified, and ? Summers. (Below, Russ Johnson Collection.)

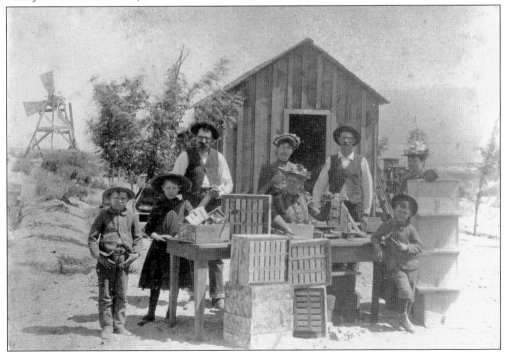

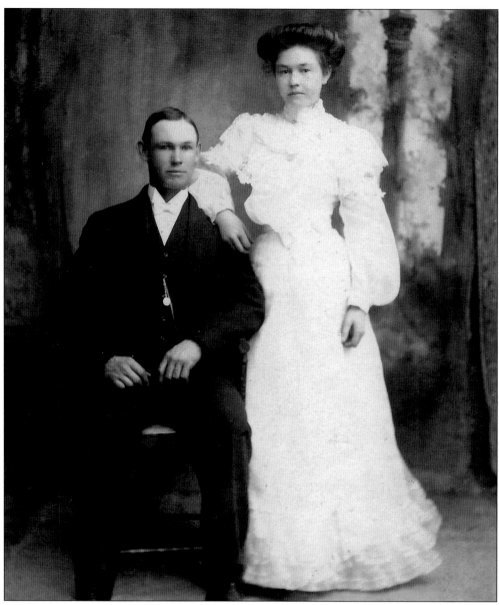

Charles and Lena (Gish) Partridge are shown here on their wedding day in 1904. They raised a family of nine children, whose descendents still live in the valley. Charles' family came to the valley in the 1880s, Lena's in the 1890s. Both families homesteaded just south of Bishop. They typified the spirit of 19th-century Owens Valley settlers. The Partridges had a diversified 2,000-acre farm of livestock, grain, fruit, corn, and beehives. As the Bishop economy expanded and ebbed, Charles became more involved in civic affairs serving on the BUHS board of trustees and later became an Inyo County supervisor. He was a prominent member of various irrigation committees and negotiated with the Los Angeles Department of Water and Power over water rights. Partridge laid out the trails in the Bishop Creek watershed, maintained the roads, got the highways paved, and supervised both Bishop Airport constructions, which all contributed to the beginnings of the tourist economy. After his death in an accident on an unmaintained Mojave highway, Lena took over the ranch at the age of 55. (Partridge family collection.)

Born in Virginia City, Willie Arthur Chalfant (1868–1945) moved to the Owens Valley as a child. He became editor and publisher of Chalfant Press and the *Inyo Register* and became known as "Dean of California Newspaper Editors." In the photograph below, he stands left of writer and advertising manager C. Lorin Ray. Chalfant is in front of a gas-fired linotype machine. He used his newspaper to vehemently oppose the City of Los Angeles in its struggle to control the valley's water. He also opposed the local leaders who encouraged valley ranchers to sell to the southern metropolis. Of a gregarious nature, Chalfant was a member of nearly every fraternal and service club in Bishop. Chalfant Valley, just north of Bishop, is named after him. The *Inyo Register* is still published.

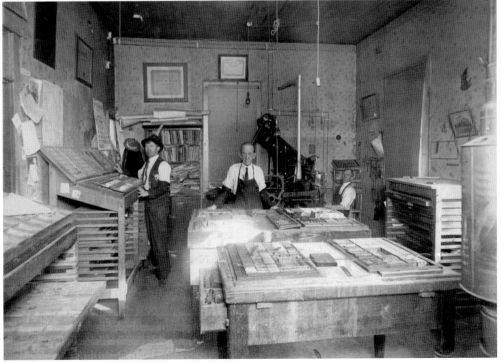

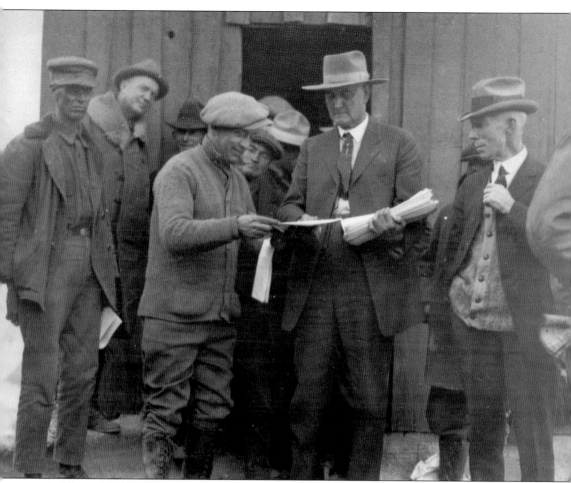

In November 1924, Inyo sheriff Charles A. Collins and district attorney Jess Hession serve H. P. Beatty with a "John Doe" warrant to reopen the aqueduct at the Alabama floodgates where he and others had diverted water back to the river during the conflict in an incident known as the Picnic at the Alabama Gates. The sheriff holds warrants for the many participants who politely refused to go along with the orders. Collins was a Bishop man and probably knew everyone in the crowd. Much of the time, however, tensions ran high during the 1920s in the Owens Valley, and most historians agree that it is surprising that no one was killed. Collins Road was named after the family of Charles Collins. (Fresno Historical Society photograph, Laws Museum Archive.)

George Rome stands with his water wagon in 1914 (above). His son, Robert, seated on Bessie, the horse, accompanies him. In the days before paved roads, George watered Bishop streets starting at 6:00 or 7:00 a.m. In the background was George's lot on Pine Street next to Bishop Union High School. Even in the legendary harsh winter of 1933, George Rome (right) and Bob Rome (left) are delivering milk at the corner of Grove and Home Streets (below). George was an immigrant from England and, like so many Owens Valley residents, had to have diverse sources of income. George also was a mail carrier, worked for the Los Angeles Department of Water and Power, and drove the school bus.

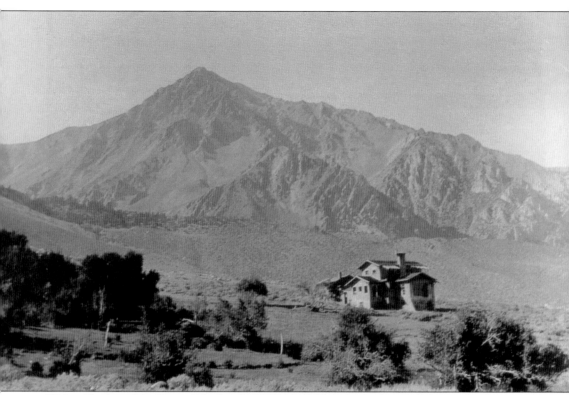

Walter Howlison MacKensie Zahr Pritchard (1866–1956) built the Artist's Cabin in the Buttermilks in 1914 and furnished it with antiques from his multiple travels in Asia and the South Pacific. The mini-mansion is pictured here in 1929. Pritchard was a well-known artist in his day and was often referred to as Merman for developing the technique of painting with oils underwater. Most of his paintings were of underwater scenes in such places as Tahiti, where he dove before modern scuba equipment was invented. His first exhibit coincided with the Great Earthquake of 1906 in San Francisco. He also enjoyed the isolation of the deserts in Arizona and Bishop. In the shadow of Mt. Tom, this arts and crafts style house eventually was abandoned, and Pritchard failed to pay the property taxes. Photographer Curt Phillips bought it from the State of California in 1942 for $250. A group of teenagers holding a party in it afterwards accidentally burned the house before Phillips could renovate it. (Charles Partridge.)

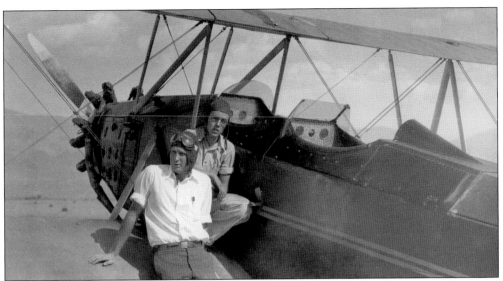

Curtis Phillips (left) (1910–1985) and Howard McAfee (1916–1993) sit on the wing of a biplane that may have been used for Phillips' aerial photographs. He was the primary professional photographer in Bishop from 1935. Since he was interested in museum work, Phillips created a visual record of Eastern Sierra events and places. His photographs and negatives are archived at the Laws Museum. Howard McAfee's Mono County family ranch was sold to the City of Los Angeles, so they moved to Bishop. He spent time working at Richmond's Kaiser Shipyards during World War II and served in the army on Okinawa. The aerial shot below is of Bishop looking east past Bishop High School in the foreground.

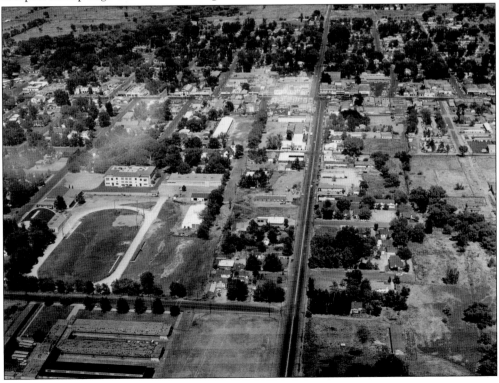

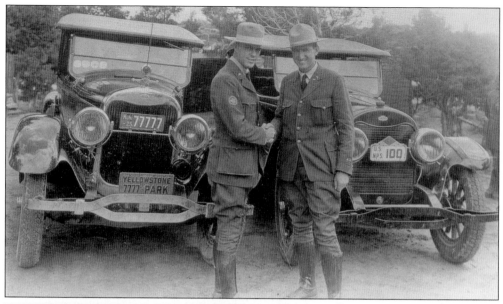

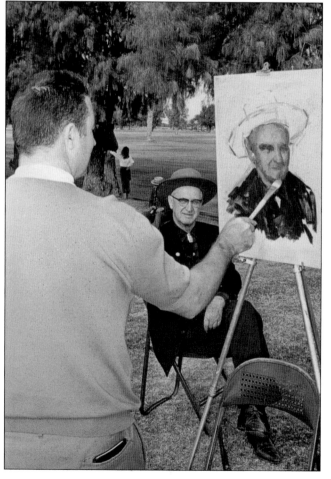

Born in 1890 in Bishop, Horace Marden Albright was the son of the local undertaker. Horace went on to the University of California, Berkeley and to Georgetown University in Washington, D.C., for his law degree. Albright had a major role in creating the National Park Service Act of 1916 and was the director after Stephen Mather. He was also the superintendent of Yellowstone National Park and can be seen here in the 1920s in front of Yellowstone's Lincoln touring cars (above). After retiring from a park service that he greatly expanded, he was vice president and later president of United States Potash Company. Pres. Jimmy Carter presented Albright with the Presidential Medal of Freedom, America's highest civilian award, which recognizes exceptional service to the country. Albright is seen left getting his portrait painted in 1969. He died in Van Nuys in 1987.

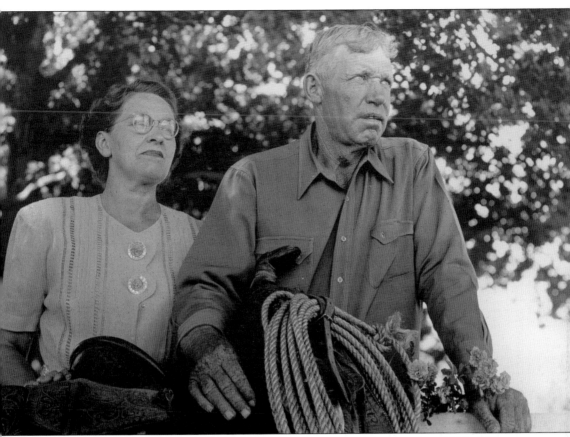

Jess and Mildred (Knapp) Chance are pictured in 1947 on one of their ranches. Mildred Knapp came to Owens Valley and taught at Valley School located on the 4C Ranch south of Keough's Hot Springs. After she married, local parents held a petition drive to allow her to keep her job because in those days female teachers had to be single. She went on to serve on the school board for 14 years. Jess came to the valley in 1902 with his parents and began raising cattle before age 12. He then set about building a cattle business with several ranches around Bishop in the Warm Springs district, Round Valley, Long Valley, and Tonopah. For many years, Chance was the local state brand inspector and a member of the Cattlemen's Association. He served on the advisory board of the Bureau of Land Management and was Bishop Homecoming president. Chance was a member of just about every fraternal organization in Bishop. (Curt Phillips.)

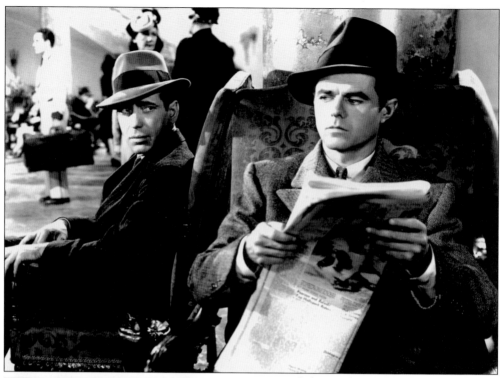

Elisha Cook Jr. was better known as "Cookie" to Bishop folks. Although he was born in San Francisco, he lived in Bishop most of his life in a modest home on Mandich Lane. He would commute to Los Angeles to act in over 200 films and also had many television roles. A colorful character, Cook could often be spotted in his old black Cadillac combing the dusty back roads. He can be seen here with Humphrey Bogart (above) in 1941 in the *Maltese Falcon*, in which he played Wilmer Cook, and at the Laws Railroad Museum (left). He once said that he was never sent scripts; the studio would call, and he would just show up. He died in 1995 at the Big Pine Care Center. Cook's last role was in the TV series *Magnum, P.I.,* with Tom Selleck. (Above, Warner Brothers.)

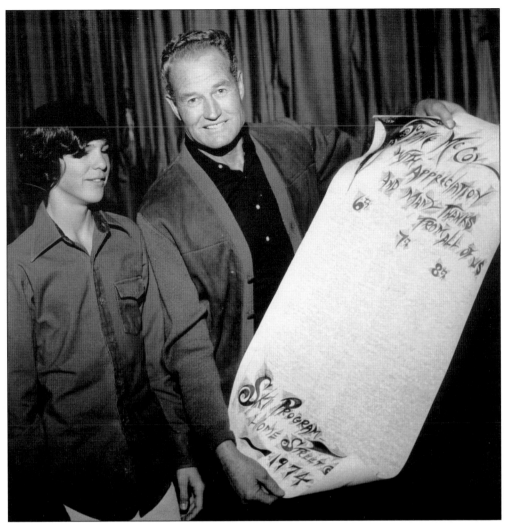

Dave McCoy, a Bishop resident, founded Mammoth Mountain Ski Area and turned it into one of the country's top resorts. He discovered the location while working as a hydrographer for the Los Angeles Department of Water and Power. He then built a rope tow on the north slope of Mammoth Mountain. The first lodge was built in 1953, and the first chairlift opened in 1955. Since then, he has helped the local community, especially in the area of education. In this 1974 photograph, Clay Greer, student body president of Bishop's Home Street School, presents McCoy with an honorary service award for his contributions to youth ski programs. McCoy was a key figure in the founding of Cerro Coso Community College. Now retired, he has become an exceptional nature photographer and can be seen exploring the backcountry on his ATV. (Curt Phillips.)

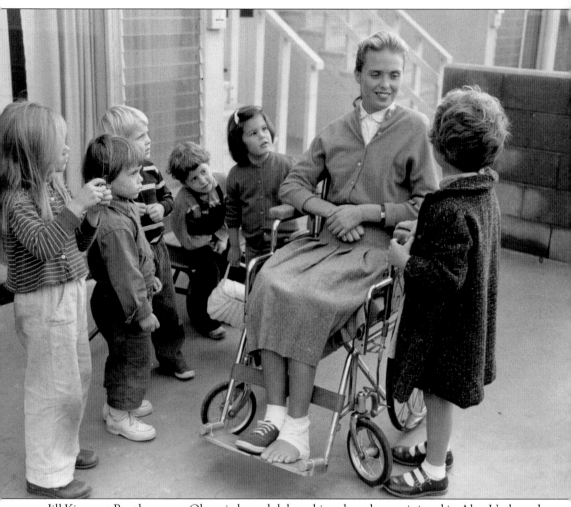

Jill Kinmont Boothe was an Olympic-bound slalom skier when she was injured in Alta, Utah, and became quadriplegic. However, most people say her greatest accomplishments happened after the accident. She went on to receive her degree from UCLA and her teaching credentials from the University of Washington when most universities would not accept handicapped people for teaching programs. Two Hollywood movies were made about her life, *The Other Side of the Mountain* and *The Other Side of the Mountain, Part 2.* Jill then taught special education in elementary school in Bishop for over 30 years. Now retired, she is an outstanding watercolorist and role model. Kinmont is pictured here with some of her students. (Jill Kinmont Boothe.)

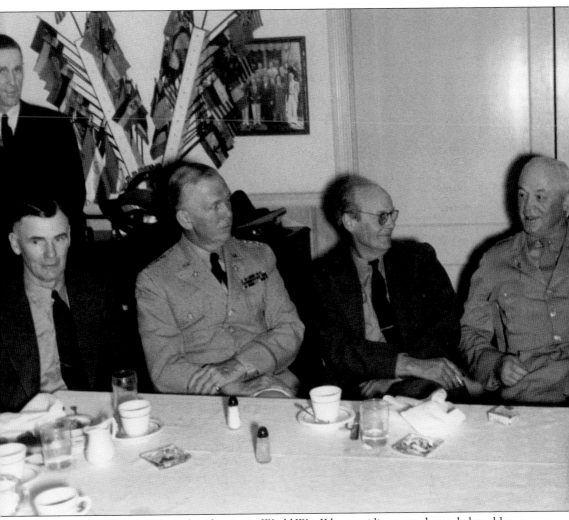

In the summer of 1944, Bishop played a part in World War II by providing a much-needed weeklong R & R to two national military figures—four-star generals George C. Marshall (second from left) and Hap Arnold (far right). They are pictured here with Roy Boothe (left), superintendent of the Inyo National Forest, and G. B. Shaw (third from left). At the end of the top-secret Sierra fishing and pack train trip, the generals threw a banquet at the Golden State Café for the organizers. After the banquet, Boothe flew to Washington, D.C., with the officers. Marshall went on to author the Marshall Plan for the peaceful rebuilding of Europe and become Truman's secretary of state.

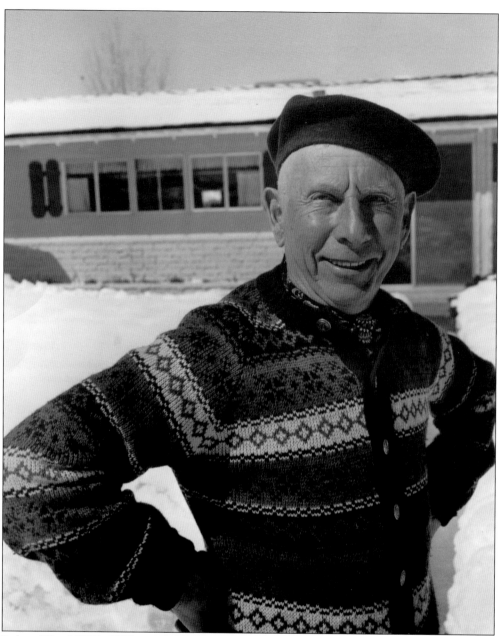

Robert Wood (1889–1979) was a prolific and popular painter. Born in England, he moved to the United States as a young man and became a wanderer, painting as he traveled. His prints were in the homes of millions of Americans. These sales provided him and his wife, Caryl, with a comfortable living. He lived in Bishop twice—once starting in 1940 and then for the last 20 or so years of his life. Wood died just before his 90th birthday, and after his Christian Science service, his ashes were scattered on Mt. Tom. The stunning scenery of the Eastern Sierra has attracted many landscape painters over the years, such as Scottish born Robert Clunie (1895–1984) and Richard Coons (1929–2003.) Coons's wife, Wynne Benti, still runs the Coons Gallery and carries many local artists' work. The Inyo Council for the Arts has special exhibits of regional artists and artisans. (Curt Phillips.)

Raymond Stone, noted Paiute sculptor, lived in Big Pine and attended Sherman Indian School in Riverside and later worked at Stewart Indian School in Nevada and at Bishop Union High School. He learned the art of carving from his father, Tom Stone. Raymond's stone sculptures are on exhibit at the Smithsonian in Washington, D.C. These carvings are made of pipestone from Pipestone National Monument in Minnesota, a sacred site. In addition to his art, Raymond also was involved in bringing people back to their traditional Native American spirituality, which included ceremonies, sweat lodge, and pipe. He was a man of no pretense and a well-loved figure in the Owens Valley.

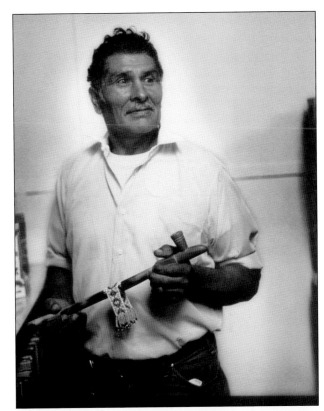

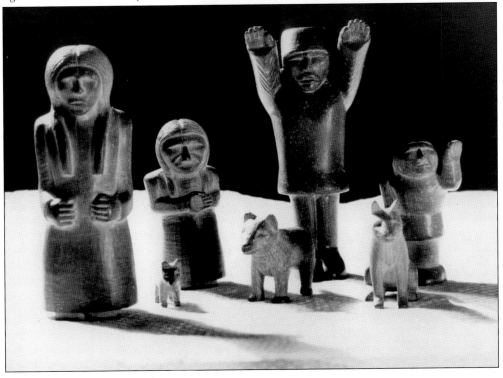

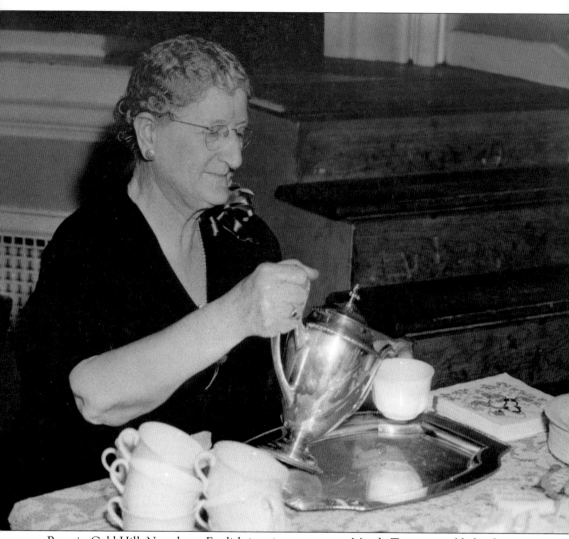

Born in Gold Hill, Nevada, to English immigrant parents, Maude Truscott molded at least two generations of Bishop residents. She was a teacher and then principal at Bishop Grammar School. After her father died, the family moved to the Owens Valley. Truscott attended the University of Nevada in a time when it was not the normal thing to do for young women. She taught at Laws for a couple of years, then went uptown to Bishop where she worked for 46 years before retiring in 1941. Truscott received a diamond ring from local residents as a retirement gift. With Miss Truscott, students behaved. Howard Holland still remembers the feel of her wooden ruler across his hands. In this image, she serves proper English tea. Everything about her was proper. To loosen up, she enjoyed being an outstanding horsewoman and getting into discussions at the Athena Club, Bishop's study and intellectual group.

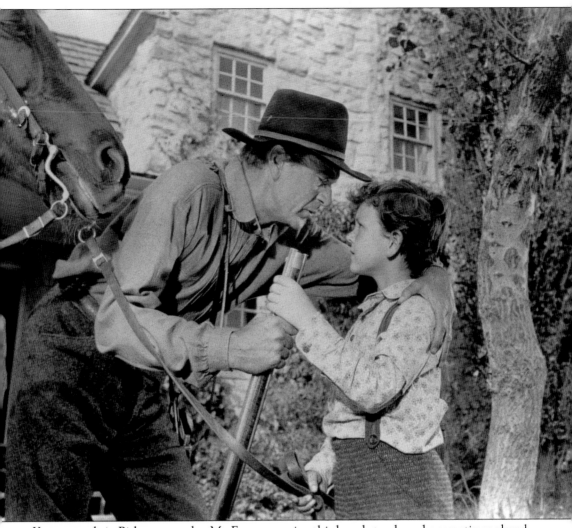

Young people in Bishop remember Mr. Eyer as a caring third-grade teacher who sometimes played his guitar for them. Perhaps teaching was his greatest role, but Richard Eyer had a childhood that kids could only dream about. In the 1950s, he became the highest paid Hollywood child actor. He played the kindly little genie, Barani, in the *Seventh Voyage of Sinbad,* turning himself into a ball of fire, and was manhandled by Humphrey Bogart in *The Desperate Hours.* Eyer was Gary Cooper and Dorothy McGuire's son in William Wyler's *Friendly Persuasion,* pictured here. He starred in *The Invisible Boy* with Robbie the Robot, which has become a cult classic. There were also many roles in TV series, including a regular one on *Stagecoach West.* He moved to the Eastern Sierra in 1970, opened Rich's Britches clothing store, and raised a family. He dedicated himself to Bishop's schoolchildren for 29 years until his retirement in 2006. Nowadays Eyer enjoys being with his dogs, winter fishing in Baja, and volunteering at the Inyo animal shelter. (Allied Artists.)

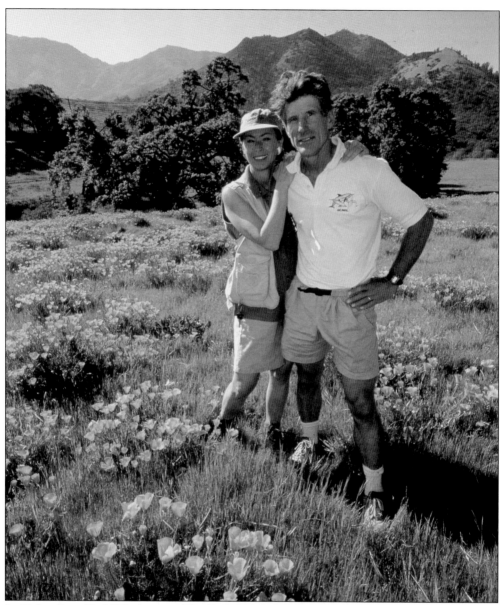

In Galen Rowell's 2002 obituary, *The Guardian* newspaper of Great Britain described him as "a cross between Sir Edmund Hillary and Ansel Adams." It also noted that he was "the most famous outdoor photographer in the world." Rowell and his wife, Barbara, opened their Mountain Light Gallery in the old Bank Building at the main intersection in town. Barbara was also an adventurer, flier, and outstanding photographer. Even though Galen had traveled to all seven continents, he and Barbara chose Bishop to be their final home and extensively photographed the Eastern Sierra. In 1984, he received the Ansel Adams Award for wilderness photography and in his lifetime wrote 18 large-format books. He scaled many of the world's tallest peaks and went on major expeditions for *National Geographic*. Rowell hoped that his photographs met a higher purpose, that of preserving the last beautiful places on the planet. He once said that his life was a "continuing pursuit in which art becomes adventure, and vice versa." The Mountain Light Gallery is still a leading tourist attraction in Bishop. (Mountain Light Gallery.)

Six

MAKING A LIVING

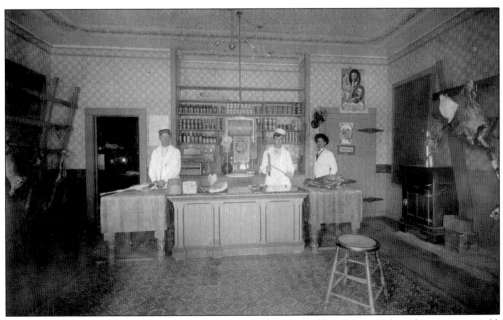

As the population increased, commerce expanded. Many old-timers say that the area was self-sufficient in food. In this butcher shop in downtown Bishop, Sabert Leidy (left), Karl Keough (center), and Perry McGee pose between meat hooks on both sidewalls. The butcher blocks would be the envy of any gourmet kitchen today. In those days, all beef was grass-fed, which is a current gourmet economic possibility for Bishop ranchers.

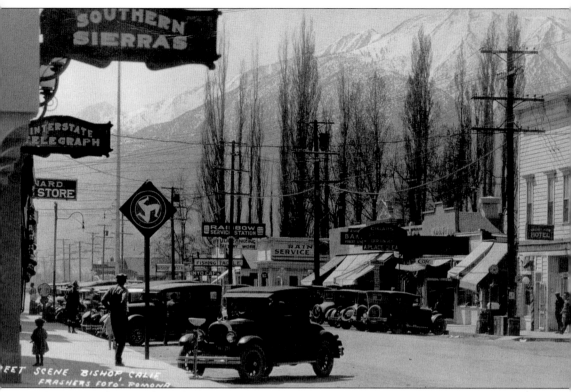

By 1903, Bishop was the only incorporated city in Inyo or Mono counties. The town's government was responsible for maintaining the surface condition of Main Street. However, on January 1, 1926, the California Highway Commission took over the maintenance of Main Street. Four months later, the city fathers requested that the state pave Main Street, which it subsequently did. In March 1929, Bishop passed an ordinance legalizing the use of stop signs on Main Street. A bypass has been talked about since 1920 and is still a torrid topic today. This winter shot looks south on North Main. On the far right is the Valley View Hotel and in the distance, the Coyote Front of the Sierra Nevada. Bishop is still the only incorporated city in Inyo County. (Burton Frasher.)

Looking west on West Line Street in the early 1920s, on the left corner is Mark and Cohn's Dry Goods. The next storefront is a dentist's office, then Gosney's Shoe Repair, and Nelligan's paint shop. To the right on the corner of Line and Main are Vondy's Café followed by a service station, Greniger's tin shop, and finally Bishop Elementary School.

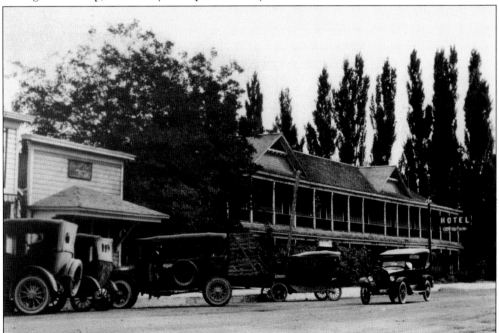

The elegant second Hotel Istalia (pictured here) was rebuilt after the first one burned around the time of its March 1907 opening. Istalia Hotel Company was incorporated in May 1907, and its investors were prominent local Inyo-ites. The second Istalia Hotel was destroyed in a blaze in 1925. It was located at the corner of Short and Main Streets, the site of the present Golden State Cycles.

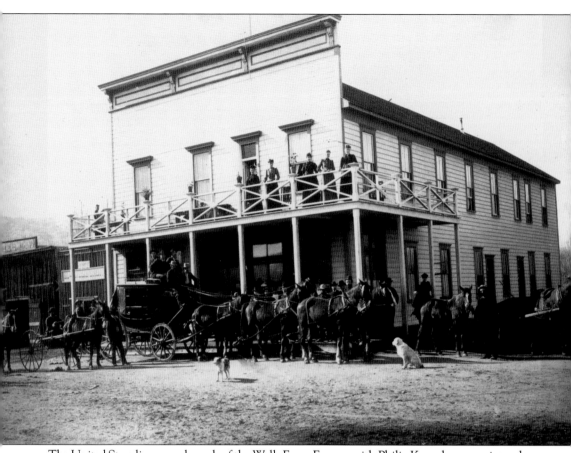

The United Stageline was a branch of the Wells Fargo Express with Philip Keough as superintendent. Heading south from the Valley View Hotel, the coach stops were at the (future) Partridge Ranch, Swansea, and Little Lake. Heading north, the route went along the present Fish Slough Road and stopped at Fish Slough, Yellow Jacket, Adobe Meadows, Taylor, and Benton. At Benton the road split toward Bodie, stopping at Mammoth, or to Aurora by way of Candelaria. The time from Mammoth to Bodie was 12 hours, averaged 10 miles per hour, and cost $25. Bishop to Independence was $5. It was three hours from Independence to Lone Pine. Besides passengers, the coaches also carried mail, and they stopped in Bishop three days a week. These vehicles were made in Concord, New Hampshire, and were called Concords. They could carry eight passengers and were somewhat comfy. However, when the way got sandy, the passengers had to get out and walk. The stage line went out of business with the coming of the train in 1883, even after discount fares were given.

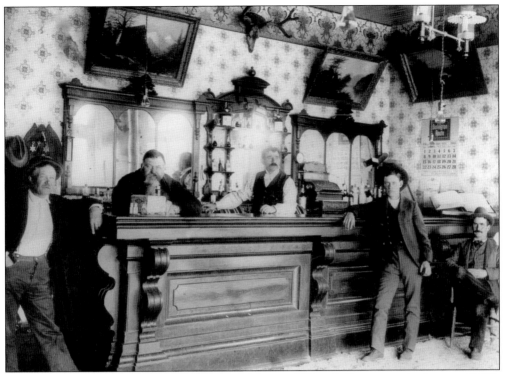

The Valley View Hotel, on the corner of North Main and Church Streets, was built around 1890. Inside the hotel bar, "Dutch" John Albers is the young man who stands at the front in 1903. Albers was supposed to be related to the Albers Flour folks, but in Bishop he was a blacksmith.

The Vienna Bakery was originally known as George W. Neil's Crunch Candies. In 1908, Robert Schoch acquired the Vienna Bakery, which later became the Bishop Bakery, home of the famous Sheepherder Bread. The recipe was Basque in origin and acquired from the Basque sheepherders who tended their flocks in the Eastern Sierra. The trademark was later obtained by the Schat family, who operates the bakery today.

The Watterson Brothers originally owned the site of the Kittie Lee Inn. In 1924, Matt Wilkinson purchased the land and built the inn he named after his daughter. In 1925, it was bought by the Whorff family (the family of Shirley Fendon of Fendon's Furniture). The inn was a local showplace with 49 guestrooms, and Hollywood celebrities such as Cary Grant sometimes stayed here. The dining room was considered the place to go for upscale lunches and dinners. In 1939, the dining room became a dorm for Civilian Pilot Training, the local airport being a base. In 1950, the Copper Kettle Coffee Shop opened at the inn. In 1964, the north end of Kittie Lee was torn down. In 1991, the south end was remodeled into the present Whiskey Creek Restaurant. The buckeye tree that still grows near the front deck was carried from the Wilkinson's home state of Texas and planted by Kittie Lee.

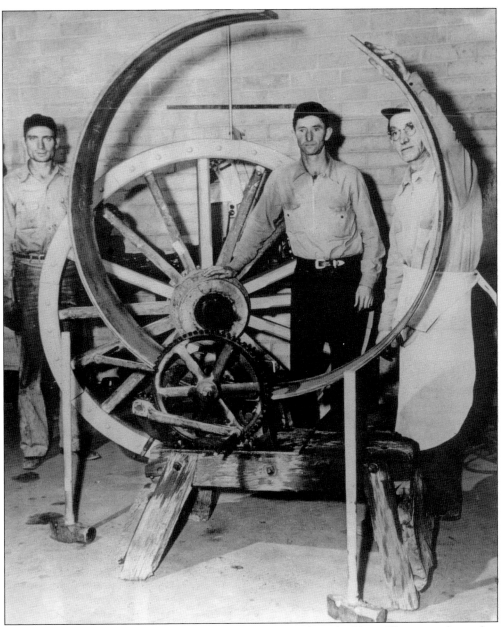

At the south end of town, travelers can still see the Hartshorn building. The original one that stood on that site burned and was rebuilt in the early 1930s. Carl Williams (left), Elbridge Hartshorn (center), and Finley Hartshorn are demonstrating how wagon wheels were made. In the dangerous world of wheelwrighting, the metal rim had to be put on the wooden wheel when the metal was hot, so a group of people had to be on hand to pour water to make sure the wood did not burn. The cooling process also shrank the metal to the size of the wooden wheel. Some of the Hartshorn wheels went on the borax 20-mule wagons. The family also made the wheels on the cannon at the Bridgeport courthouse lawn. In addition to wheelwrighting, the Hartshorns did blacksmithing and spring making. They later added welding to the list. The welding business is still called Hartshorns but is now owned by Greg Wines.

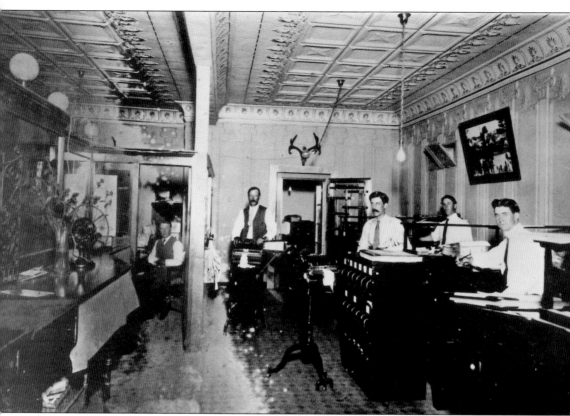

Referred to by many as the Watterson Brothers' Bank, the Inyo County Bank was located at Academy and Main Streets. Included in this photograph are Mark Q. Watterson, Wilfred W. Watterson, and A. D. Schively. The Wattersons also owned First National Bank. Both Bishop banks closed August 4, 1927, with the following message tacked on the doors: "We find it necessary to close our banks in the Owens Valley. This result has been brought about by the past four years of destructive work carried on by the City of Los Angeles." The two Wattersons spent time in San Quentin for embezzlement, and many locals lost all of their money. Some of the Bishop folk did not believe that the embezzlement charge was just but said the brothers had lent too much money because of the economic depression that the City of Los Angeles had caused in the valley.

The water-powered Standard Flour Mill was located west of Bishop on Bishop Creek about where Southern California Edison Plant Six is today. It was built by Joel Smith and Andy Cashbaugh but owned by Harvey Russell and managed by John Blair and a Mr. Dugan. Some of the workers are pictured here. There were two other flour mills in the area. The Jones family in Round Valley owned one, and the other gristmill was the Sierra Flour Mill between Johnston Drive and the canal on East Line Street, the latter owned by Dave and Betty Kelso. In the early part of the 20th century, there were numerous grain fields in the Owens Valley. The farmers would take their grain to the miller, who would grind it, payment being a certain percentage of the product.

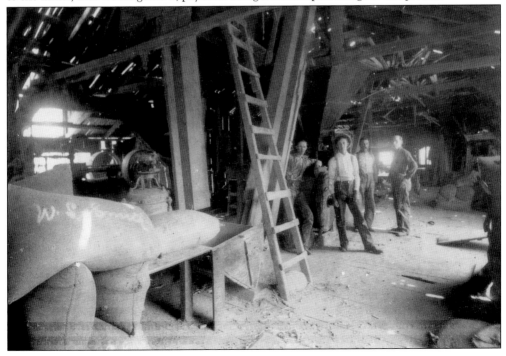

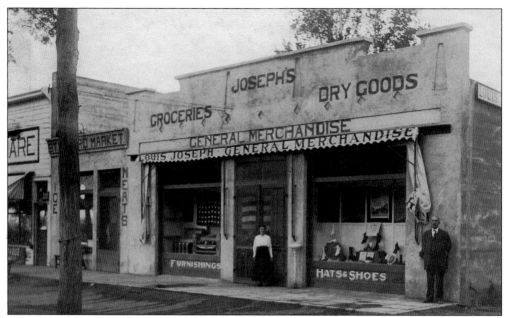

After working in the Levy Hotel in Independence, the Joseph Family moved to Big Pine in 1895 and established Joseph's store. This store furnished Inyo-ites with food, drugs, and farm and mining supplies. In 1935, they opened the Joseph's stores in Bishop and Lone Pine. When the present Bishop facility began business in 1940, they were selling one pound of coffee for 24¢. Joseph's stores in both towns are still open.

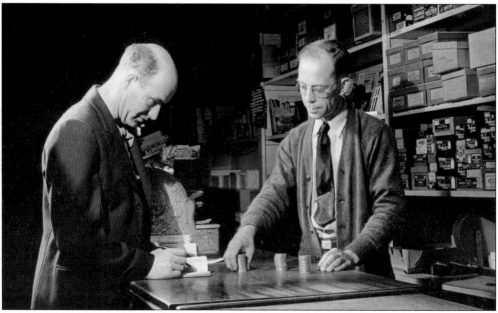

Louis Garrigues stands behind his counter at the Piñon Bookstore, counting something seldom seen any more— silver dollars—while Henry Jackson looks on. After Louis retired, his son, George, took over the store. Opened in the mid-1920s, the Piñon sold books, maps, art supplies, greeting cards, toys, and school supplies. It was a treasure trove for kids who purchased their comic books here. (Curtis Phillips.)

A worker takes a break and leans against a transformer before putting it in place at Plant Two on Bishop Creek in 1908. Between 1905 and 1913, the Nevada-California Power Company built the Bishop Creek hydroelectric complex. For years, it was enough to supply power to the Owens Valley and some Nevada mines. The surplus went to the San Bernardino area. This complex is now operated by the Southern California Edison Company.

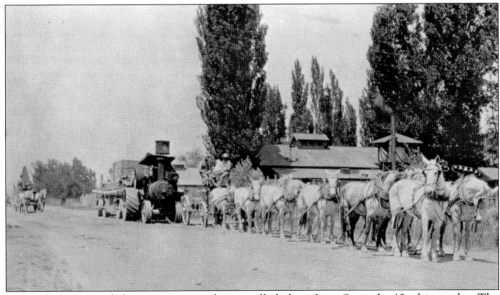

A. J. Schober owned this steam tractor being pulled along Line Street by 12 white mules. The tractor was a 22-ton Daniel Best and was used in building the Saline Valley Salt Tram. On its way there, the rig collapsed three culverts. The apparatus was sent from Laws up Bishop Creek in the construction of the power plants. On its way, this behemoth collapsed timbers on the Owens River Bridge.

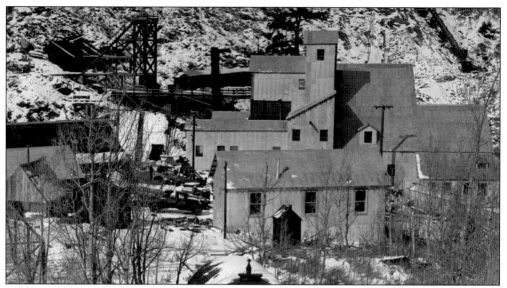

In 1890, gold was discovered on the north face of Bishop Creek Canyon. The subsequent mine (above) went through several reorganizations—the Bishop Creek Gold Company, Gaylord Wilshire Mine, the Bishop Creek Mine, and finally the Cardinal Mine. Wilshire was the developer of Long Beach as a resort and the socialist editor of *Wilshire Magazine*. In order to attract investors, he boasted, "It is indeed the world's greatest gold mine." By 1915, it had a ten-stamp mill. From 1933 to 1937, $1.5 million in gold was extracted. From the 600-foot main shaft, silver and copper were also extracted. The mine buildings are shown in 1930. Miners, such as the unidentified men below, worked seven days a week with an occasional day off. Their archrival in softball was the team from the L.A. Department of Water and Power. The mine closed in 1938 when high grade ore was depleted.

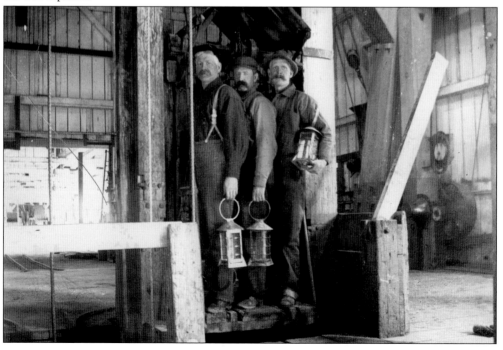

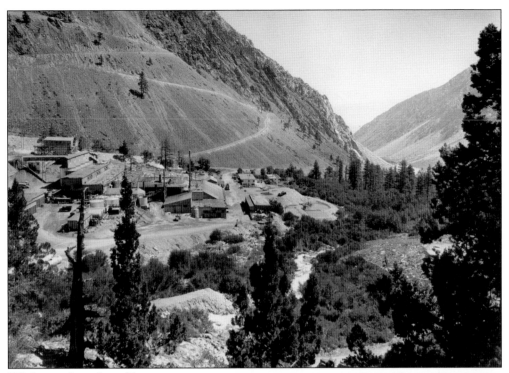

While searching for gold in 1916, tungsten and molybdenum were discovered in Pine Creek Canyon by four Civil War veterans—O. E. Vaughan, A. E. and C. C. Beauregard, and James Sproul. Tungsten and molybdenum were needed for the World War I war effort, so production in the canyon grew. Since the roads were steep, pack trains were necessary to transport ore to wagons and then to the narrow gauge railway. Full-scale plant construction began in 1941, as tungsten was classified as a strategic metal during World War II. The primary tunnel at Pine Creek reached 1.5 miles in 1949. By 1970, a total of 15 million tons had been extracted from the mine, and some say it was the largest tungsten mine in the world. It closed in 2000 because of less expensive imports.

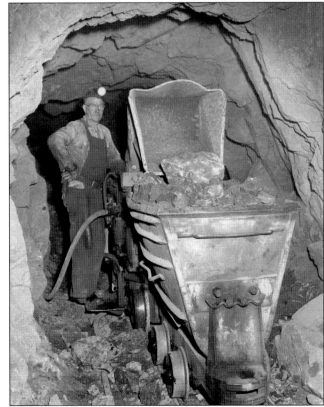

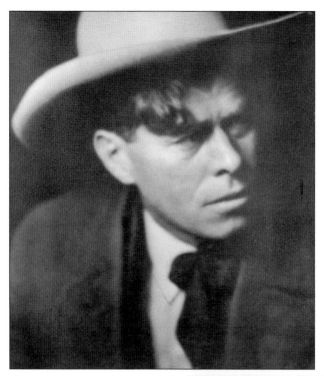

Although Lloyd Skinner (left) and Granny Skinner (below) did not live in Bishop, these photographs were taken by Dorothea Lange and are in the archives of the Laws Museum. The Skinner Family lived in the southern end of the valley near Keeler. Lloyd was a major mining figure of Inyo County, associated with the Four Metals Smelting and Mining Company, the Cerro Gordo Mine, the Christmas Gift Silver Mine at Darwin, and the Union Mine in the Russ District at the town of Reward. Lloyd was left a paraplegic in 1915 because of an auto accident but still kept quite active and died in 1926 at age 43. Dorothea Lange was one of the most famous American photographers of the 1920s and 1930s and took several photographs of Lloyd.

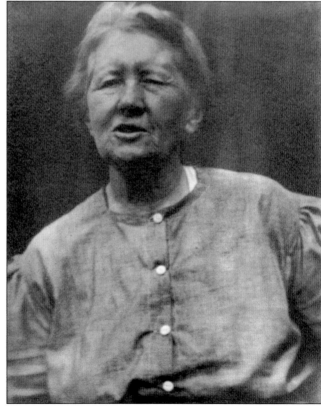

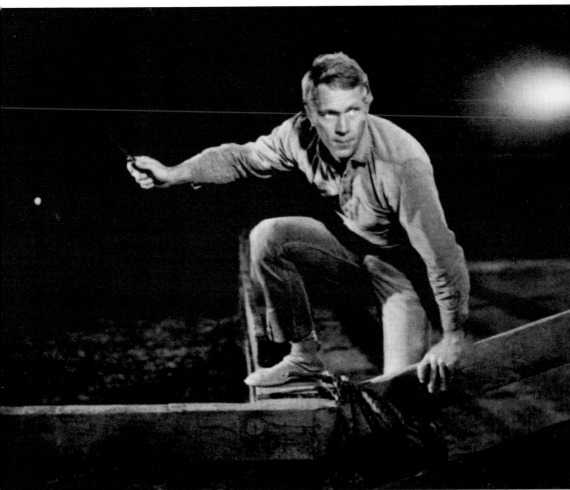

The Eastern Sierra has great scenery for moviemaking, and the Bishop area is no exception. *Nevada Smith* was made in 1966 by Paramount Pictures and directed by Henry Hathaway. It starred Steve McQueen as Max Sand, later known as Nevada Smith. In this story of revenge, Sand sets out to kill the murderers of his parents. The film used the Mammoth area, Hot Creek, the Buttermilks, Round Valley, and Laws as movie sets. Laws was supposed to be Abilene. Seen here at corrals built at Laws, McQueen is ready to get into a knife fight with actor Martin Landau, who portrays one of the killers. Some of the buildings made for the movie can be seen at the Laws Museum today, such as the Wells Fargo building and the visitors center. The Drovers Cottage unfortunately collapsed. Many local Owens Valley people were put to work on the film. When movie companies temporarily move in, the local economy benefits. (Paramount Pictures.)

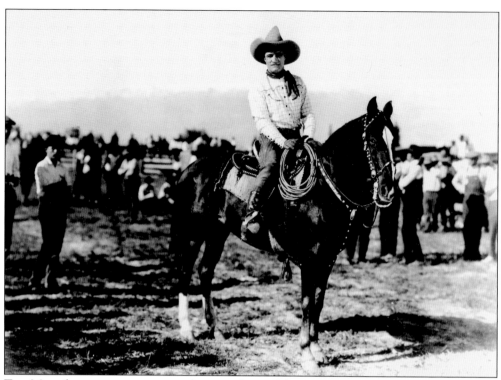

Tom Mix, silent screen superstar, is shown on his trick horse, Tony, at the Bishop rodeo grounds (above) and in a parade (below) for the 1922 filming of the movie *Just Tony*. A ticket to the event was $1 (about $13 today). Mix made around eight films a year, many of them in the Owens Valley. While filming *Riders of the Purple Sage* in 1924, he came to the aqueduct at the Alabama Gates to entertain the locals who had captured it from Los Angeles. One of Mix's favorite movie slogans was "maybe I will, but likely I won't." Much later, talkies were made near or in Bishop, such as *Will Penny, The Arrival, Joe Kidd, Night Passage, Ride the High Country, True Grit, My Pal Trigger, Air Mail,* and several others by Will Rogers and Hoot Gibson. (Chris Langley collection.)

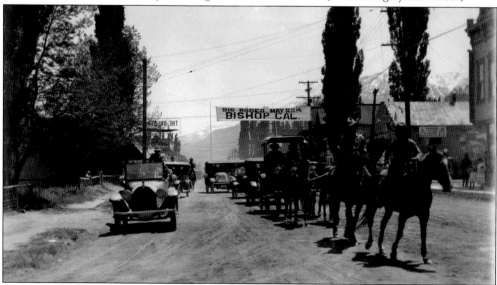

Seven

LAWS

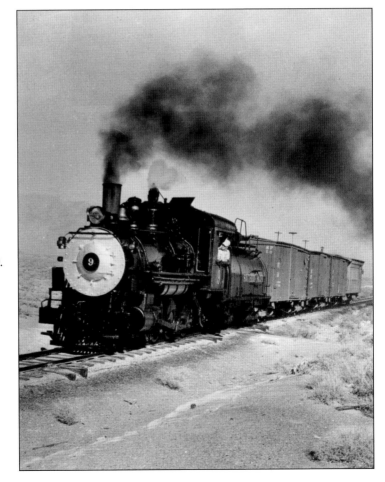

Steam engine No. 9 is heading for Laws, named after R. J. Laws, assistant rail superintendent in 1900. The Carson-Colorado Railroad was financed by William Sharon, Henry Yerington, and Darius Mills. The plan was to run it from Mound House, just east of Carson City, to the Colorado River. The line made it as far south as Keeler in 1883. The Southern Pacific Company then bought it in 1900.

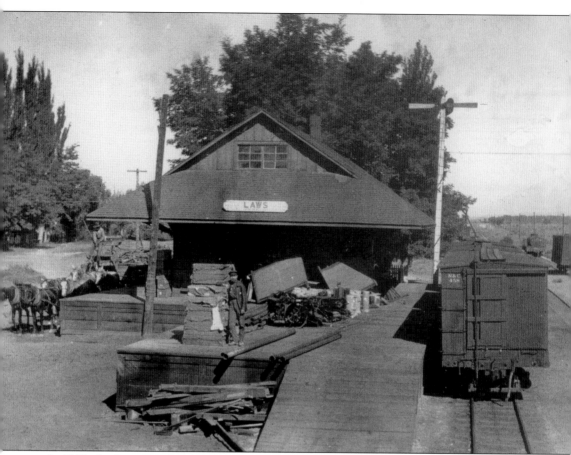

In 1880, the Carson and Colorado Railroad Company was incorporated in Nevada. The narrow gauge tracks would go from Carson City at Mound House, Nevada, to Keeler, California, with a depot at Laws, 4 miles northeast of Bishop. The hope was that the train would eventually travel to the Colorado River, but it never did. When materials or people traveled to Los Angeles, they needed to change to the wider gauge Southern Pacific at Owenyo near Lone Pine. The stationmaster in this image stands beside shipments and waits for the train at the Laws Depot in 1907. It was the first Owens Valley depot to be built on the rail line and was simply called Station or Bishop Creek. The photograph is looking north. In addition to farm produce, a variety of ores from local mines such as the Pine Creek Tungsten Mine were usually shipped northward to San Francisco mills. Lumber and food were also transported to the mines from Laws. There were 22 other stations from Carson to Keeler, not including mine sidings.

This 1890 image looks west on Silver Canyon Road, the main street of Laws. Where the stand of trees is on the left is now the visitor's center of the Laws Museum. On the right, where general merchandise was sold, is now a parking lot. Since Laws is on the east side of the valley, the soil is not as fertile. Therefore, ranchers there grew mostly hay crops and sometimes potatoes.

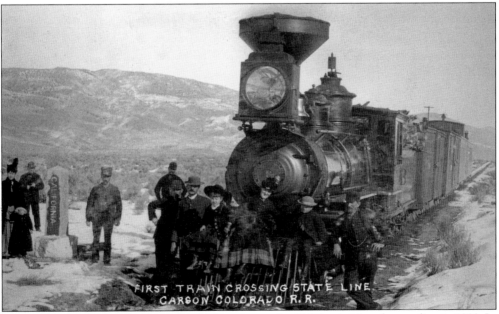

The Carson and Colorado arrives for the first time at the California-Nevada state line in 1883. In the book *Dr. Nellie*, Nellie McKnight Doyle's father called this transport "a queer, little narrow gauge train." He went on to report that a man on the train stated, "This train was built three hundred miles too long and three hundred years too soon." (William H. Hannon Library, Loyola Marymount University.)

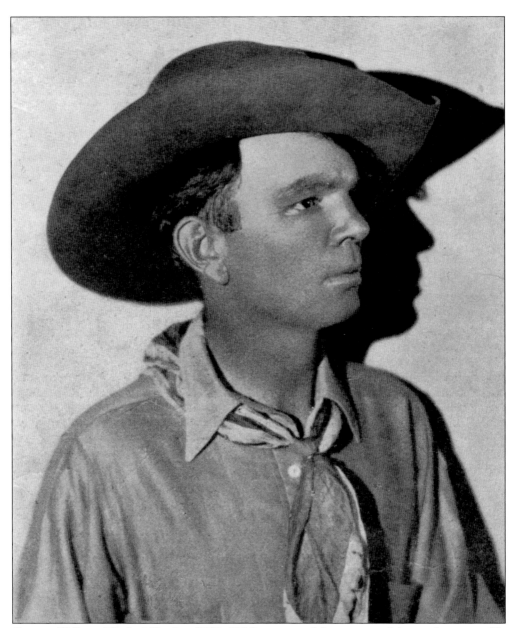

Carmen William "Curley" Fletcher (1892–1954) was one of the greatest of the cowboy poets. He was raised and educated at Laws, where he only went through the sixth grade. He was schooled by Paiute and Shoshone friends in the way of the horse and became a champion rodeo rider. Fletcher worked on several ranches and became the inspiration for Fred Harmon's Red Ryder comic books, which Curley had a hand in writing. His first poetry volume, *Rhymes of the Range*, was published in 1917, and more books were on the way. He had bit parts in such TV shows as *Gunsmoke,* and when he was short of money (which often happened because of his gambling debts) Curley went to Hollywood as an adviser on western films. His most famous achievement was the song "Strawberry Roan," which he wrote after losing a poker game; it has been recorded by people such as Marty Robbins, Pete Seeger, and Bishop resident Fiddling Pete Watercott. Curley lived in Big Pine and was a colorful character known for his practical jokes and his love of storytelling.

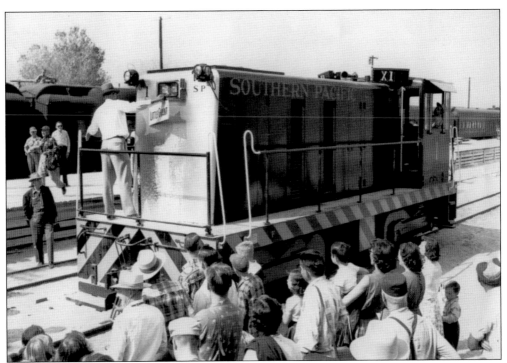

When the Southern Pacific One narrow gauge engine began operating on the Owens Valley line in 1954, it was the only narrow gauge diesel locomotive on the entire Southern Pacific system. It was christened *Little Giant* with a bottle of Owens Valley talc. After the line was closed, this little engine was sold to a mining company in Mexico where it is now stored and not operating.

Joe Smith is pictured at left while working on Sherwin Grade with surveyors from the Los Angeles Department of Water and Power probably around 1910. Smith lived in Laws where his wife, Florence (Huckaby), became the postmistress for many years. There is still a Joe Smith Road in the hamlet today.

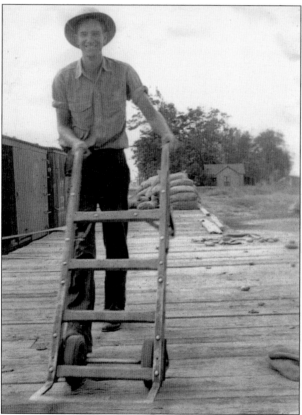

Herb and Joanne Pierce sit on the Laws Depot platform in 1939. Their father was the telegrapher at Laws. Even today, young visitors have fun on the museum grounds and find the exhibits a painless way to learn about trains and discover other treasures of American history.

Don Tatum poses while loading sacks of potatoes onto the narrow gauge at the Laws Depot. Bishop was established by supplying food to the Aurora Mining District. Once the narrow gauge railway was constructed in the Owens Valley, it became a major supplier of food to a growing Los Angeles market. Potatoes, honey, fruits (particularly pears), and livestock were the main exports to the southern metropolis.

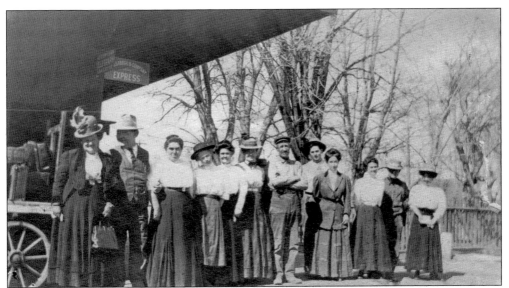

A group is gathered on the Laws Railroad Station platform to bid some folks off to San Jose. Included in the image are Libbie Newman of San Jose, the station master, Mollie Cory of San Jose, Noreen Rogers, Julia Rogers (mother of Noreen), Mary (May) Gish, and Alex McDonald, who was a blacksmith. At one time, nearly 900 people lived at Laws. Now there are about nine permanent residents.

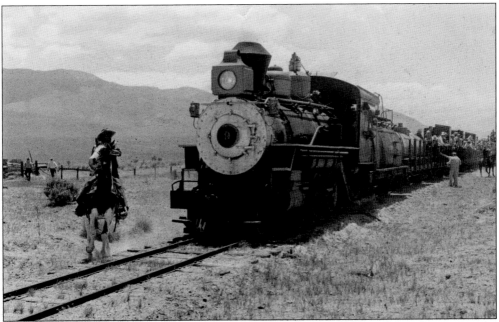

The Slim Princess Engine no. 9 (a ten-wheeled Baldwin built in 1909) makes its last run on the 36-inch gauge track into Laws in 1960. The reason Southern Pacific gave for discontinuing service was "declining and unpredictable use of line." Engine no. 9 sits in the depot to this day where children can climb aboard and ring the bell. There is hope of someday resurrecting a tourist line into Bishop.

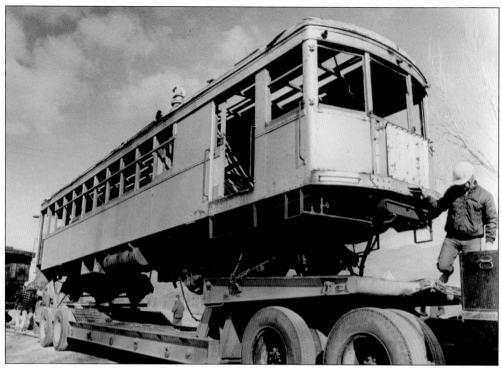

Death Valley 5 motor car was in terrible condition when donated to Inyo County by the U.S. Borax Company, which had acquired it new in 1927 from the J. G. Brill Company of Philadelphia for the borax company's new tourist business. Visitors rode from Death Valley Junction to their mining camp at Ryan until the company went bankrupt. The car was moved to Carlsbad, New Mexico, where it was used by the U.S. Potash Company. Shortly after World War II, the car fell into disuse. In 1967, it was moved to the Laws Railroad Museum for display. Restoration to nearly new condition was completed in 2004 after almost five years' effort by museum volunteers, like Max Cox, pictured below. Occasionally the car is operated and visitors can get a feel of rail travel as it was many years ago.

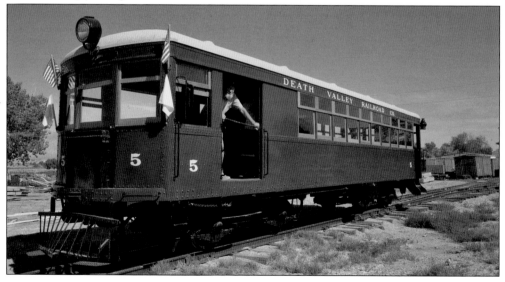

Eight

RECREATION

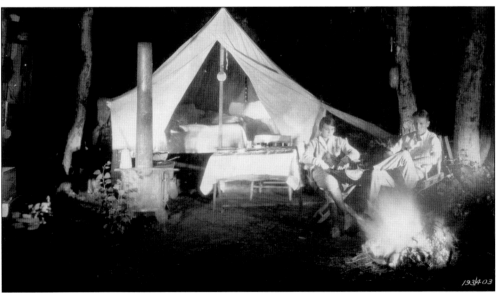

Since the highway was paved from Los Angeles into Inyo County in the late 1920s, outdoor recreation has been the economic backbone of the eastern slope of the Sierra Nevada. Here a couple enjoys a campfire in the mountains near Bishop, probably in the early 1930s. Camping equipment since that time has obviously evolved. (U.S. Forest Service photograph, Laws Museum Archive.)

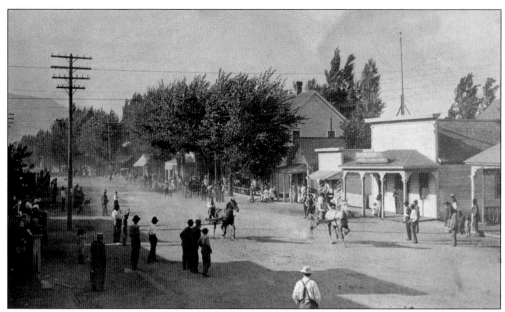

A racing event takes place in Bishop possibly on West Line Street around 1910. Racing was a favorite pastime in the town's early days, and many people had horses that were raceworthy. Tom Mix's film *Just Tony* was partly filmed at the local rodeo grounds and featured one of these Bishop horse races.

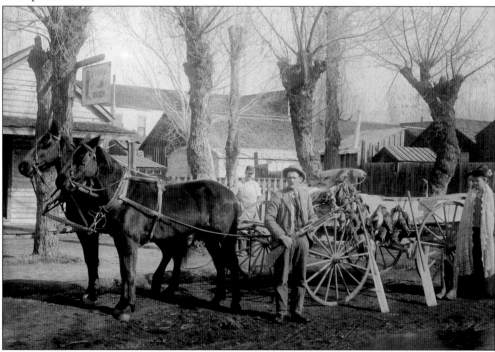

Fishing, camping, hunting, and hiking were early activities in the Eastern Sierra. Native Americans and settlers, however, fished and hunted not only for recreation but also as a means of survival. On West Line Street, an unidentified fellow shows off several brace of ducks. Annie Brooks Gosney looks on. (Matlick family photograph, Laws Museum Archive.)

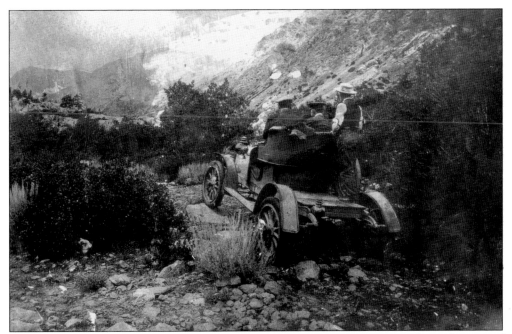

Off-road travel today is somewhat easy with SUVs and ATVs. However, in the early years of vehicular mountain travel, adventure was a little tougher. In this scene near Bishop, men are probably even wearing ties. This automobile might be a 1912 Studebaker. Any vehicle in those days that could make it over rough terrain was an off-roader.

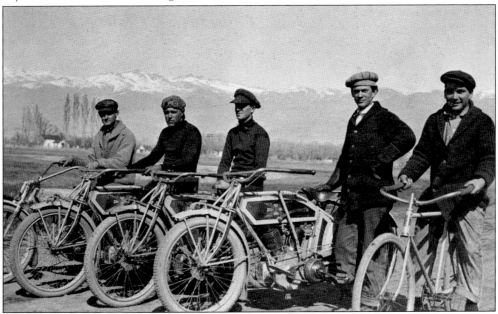

It was not a common sight to see motorcyclists in Bishop in the early part of the 20th century. These unknown bikers and a bicyclist, however, pose after being in a race probably at the fairgrounds. Their motorbikes are Excelsiors with v-shaped cylinders, which were manufactured after 1912. (Department of Archives and Special Collections, William H. Hannon Library, Loyola Marymount University.)

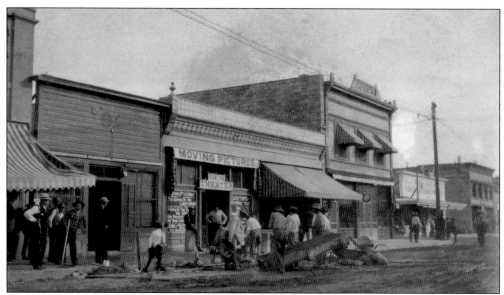

Harry Holland built the Gem Theater (above), the first movie theater in town, where Rusty's Saloon stands now. Holland came to town with a traveling Chautauqua show. He did magic tricks and acted in plays, and his favorite act was performing ventriloquism. Holland went on to own the Bishop Opera House (below), where the Masonic Lodge is today. He mainly showed movies, but there were also basketball games. On weekend nights, after various performances, the chairs were put against the wall and everyone would dance. The place burned down in 1925 after some basketball players stoked the stove and forgot about it. Holland lost his ventriloquist dummies in the fire but always enjoyed throwing his voice and puzzling people. After the fire, he built the present Bishop Theater, where he often gave free admission to the needy.

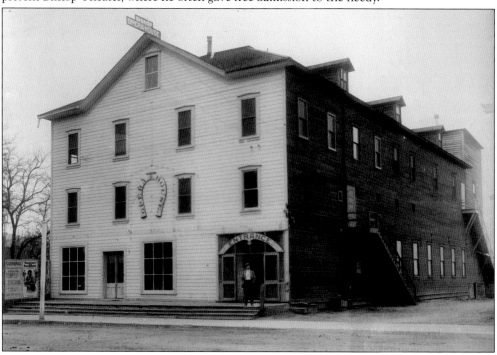

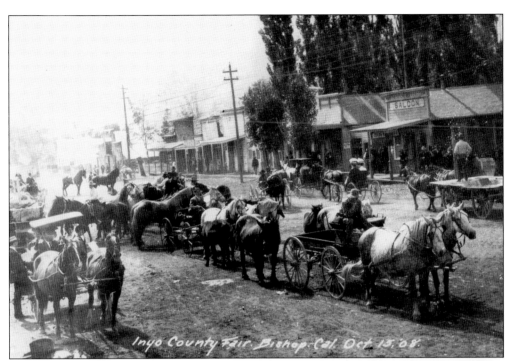

Inyo County Fair, Bishop, Cal. Oct 15, '08.

In the middle of Main Street, horse teams, wagons, and their handlers gather on October 15, 1908, for the horse show during the Inyo County Fair. This event later evolved into the Harvest Festival, which was reorganized into the Homecoming Celebration during Labor Day weekend. Bishop was well known for its fine horses, and they are still a big part of Bishop recreation today.

Norman Clyde (1885–1972) was a legendary and eccentric mountain man and climber who conquered all of California's mountain peaks over 14,000 feet high. Clyde had more first ascents of Sierra peaks than anyone else. He was a paid winter caretaker at Andrews Camp on Bishop Creek and at Glacier Lodge. (Russ and Ann Johnson Collection.)

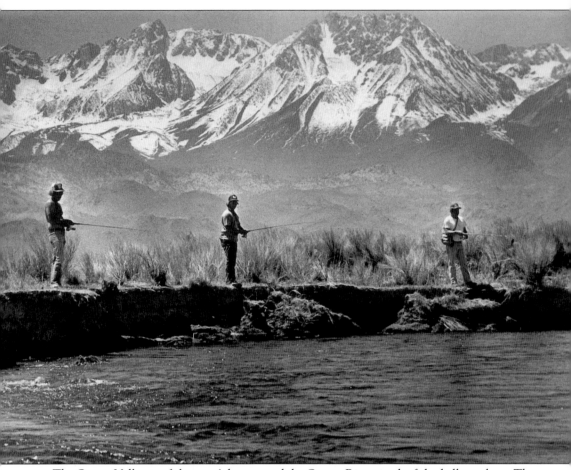

The Owens Valley is a fisherman's haven, and the Owens River can be fished all year long. There are five planted Eastern Sierra trout: rainbows (the most numerous), cutthroats (not very successful), Eastern brooks from the Eastern seaboard, European browns, and goldens (the California State Fish) only found at high elevations and native to the Upper Kern River. Plantings started in the Eastern Sierra in the second half of the 19th century, but it was a hit-and-miss operation. Fish had to be taken long distances by mule, and often these fish would die along the way. In some streams, mine pollution affected them. The Owens River south of Bishop becomes somewhat alkaline, also detrimental. Native fish include the Owens pupfish (utilized by Native Americans for dried winter food,) Owens chub, Owens speckled dace, and the Owens sucker. Other fish such as largemouth bass, bluegill, carp, Sacramento perch, and catfish were introduced. After a recent court case, it is now illegal to transport or plant any aquatic species without a permit from the California Department of Fish and Game. (Curtis Phillips.)

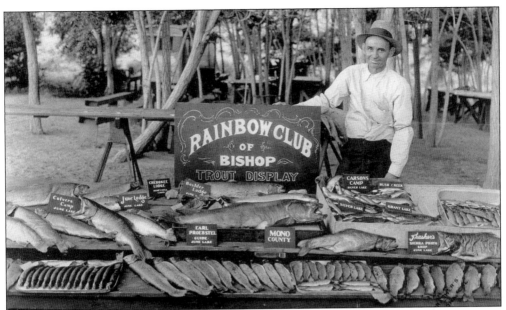

The Rainbow Club was devoted to raising funds for planting trout in the Eastern Sierra, thus helping the local economy. Dues were $1 per year, and the group had its own equipment, including a truck. In the first five years of its existence in the early 1920s, the club planted five million trout. In 1925 alone, 2.392 million fish were planted at $1 per thousand. That year, the club stocked 55 lakes and 25 streams. The philosophy was that if it was wet, it needed to be stocked. The organization had an annual competition and fish fry. The image by Burton Frasher (above) shows the display at one of the Rainbow Club's annual events. Here are some of the club members on Main Street (below). They are, from left to right, Lloyd Young, Guy Dusenberry, U. G. "Chicken" Smith, Louis Munzinger, W. P. Yaney, unidentified, Joe Riley, and Leon Orcier.

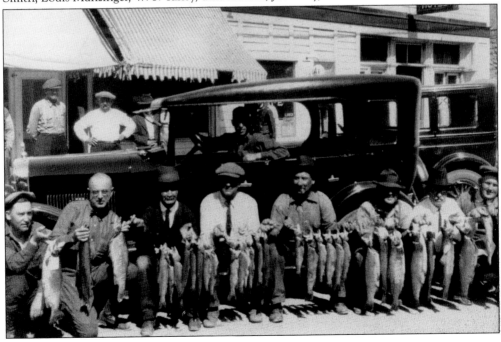

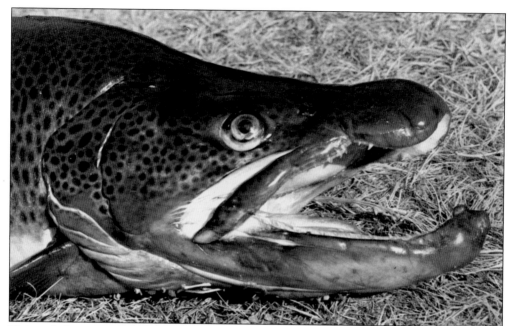

This male brown trout (*salmo trutta*) caught near Bishop in 1953 weighed in at 12.5 pounds. It was 30 inches in length and had a girth of 18 inches. The typical hooked jaw develops during the fall spawning season. Brown trout are European in origin and have been planted in the Eastern Sierra. It is a specimen like this that makes Bishop a fisherman's mecca and leads to tall tales.

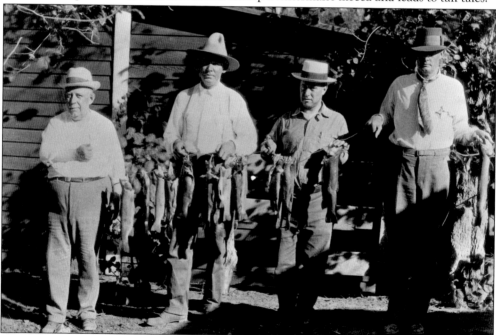

From left to right, Gus Naffiger, Tom Devine, John C. Morris, and Claude H. Van Norman show off their catches in 1923 near Bishop. Two of these gentlemen wear neckties, not something that would be seen today. Many fishermen come back to the Eastside year after year, first as children and then as adults.

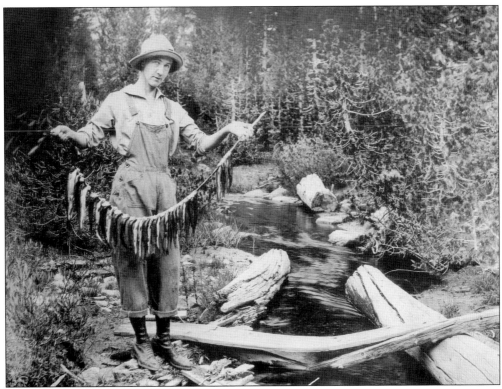

Although fishing may be traditionally considered a man's domain, this young woman shows off her abundant catch in the 1920s near Bishop. It is now estimated by *Eastside Magazine* that one out of five people engaged in fly fishing is a woman.

A California Fish and Game employee, Mark Halderman releases pheasants at the Owens River in the 1950s. Pheasants are not native to the Owens Valley, but local hunters wanted to re-create a hunting situation that had existed in the Central Valley. Native to Asia, the first ring necked birds were released in California in 1889. Few pheasants exist in Bishop today, although there is a pheasant farm. (Stephen Lukacik.)

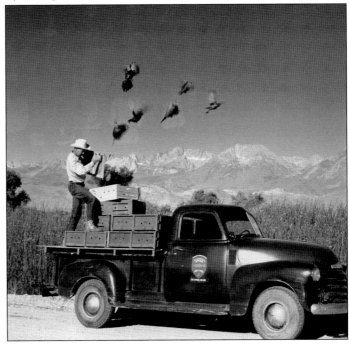

Keough's Hot Springs was founded in 1919 as Keough's Radium Hot Springs, 8 miles south of Bishop. There are three springs located here, and before Philip Keough bought the property, it had been a sacred healing site of the Paiute, *u'tu'utu paya*. Old timers can attest to the fact that the pool building is exactly the same as it was when they were kids. In the old days, there was the bathhouse where a person could take a hot bath and a dance floor where there were frequent dances with live music. Miners used to come out of the hills to dance here. They also had their famous and crowded Fourth of July celebrations where they would set off fireworks from the hill above the facility. It was sold by the Keoughs in 1926 to the City of Los Angeles, and now proprietors have short-term leases. However, the pool is opened to the public once again, and old folks who use the waters swear there is something in it that makes them feel better.

Paradise Lodge is in the foreground with Round Valley and Mt. Tom beyond. In 1931, the Gene Crosby family bought the site and built the resort when "there was just a shack there," according to Barbara Crosby. They added the 17 cabins and built the lovely dining room that sat over Lower Rock Creek. The restaurant became a place for Bishop residents to go for special occasions. (Curt Phillips.)

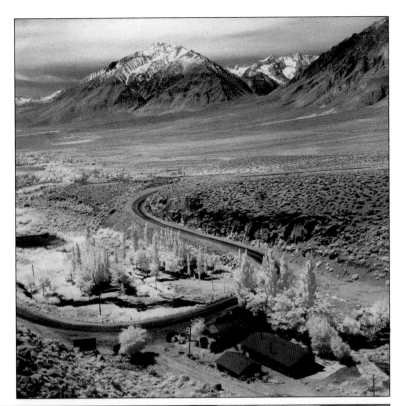

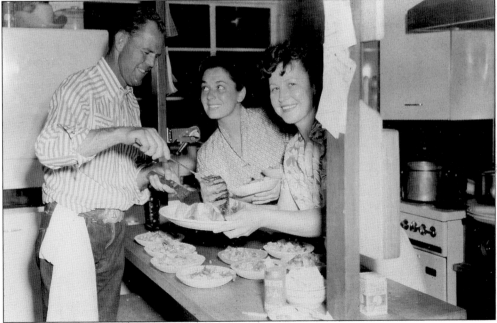

Bill Kinmont, owner of the Rocking K Guest Ranch, serves food to the actress Ruth Roman (center) and Alma Wilkerson Mack. The Kinmonts acquired the 80 acres in 1948 and built seven cabins. For the guests, they had horses, an arena, a swimming pool, and a trout pond. (Russ and Ann Johnson Collection.)

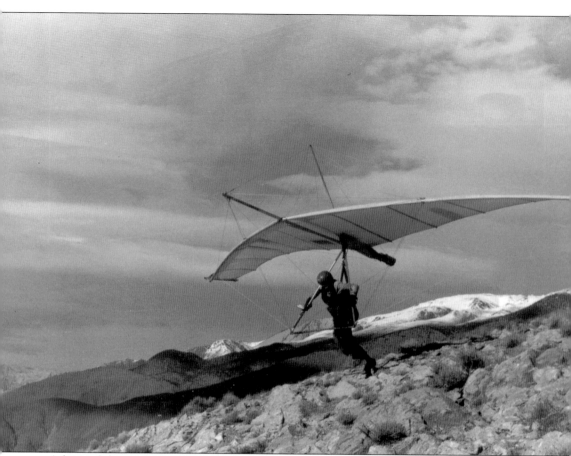

A hang glider is preparing to take flight over the Owens Valley, one of the best places in the United States for sailplanes and hang gliders. Summer conditions produce thermal updrafts with the heat rising from the desert floor along the face of tall mountains. This situation can be erratic and extreme. Don Partridge, the Bishop native pictured here, was a pioneer of hang gliding. Although he was not the first to glide in the Owens Valley, he taught himself near Bishop in 1974. Then he put the Owens Valley on the hang gliding map when he founded the first annual cross-country competition in 1978, with teams of pilots coming from all over the world in this Olympics of hang gliding. Besides Don Partridge, other major pilots involved in this sport in the valley were Tom Kreyche, George Worthington, Rick Masters, and Larry Tudor. Equipment used in the competitions helped in the evolution of these gliders. (Tara Partridge Collection.)

Nine

A Tribute to the Sierra Mules

Mules have been much maligned with terms like *mulish*, *mule-headed*, and "stubborn as a mule." But historians contend that it took mules to open the West. They often pulled wagons of settlers across the country, and the western cavalry rode mules in later years. The building of the Parthenon, the Suez Canal, even Caesar's conquests, all involved hardworking mules. Mules are still used by American military units in Afghanistan today. (Russ Johnson.)

Call it a burro, donkey, or ass, it is mostly the same thing. Furthermore, a burro will not care what you call him because he is an easygoing little brute. He can eat just about anything and does not have to drink often. This is why donkeys were well suited to miners and could carry their equipment just about anywhere and often became their only companions. They are pretty much self-sufficient and live to be 40 or 50 years old, thus the phrase "donkey's years." A female is a jenny, and a male is a jack. There are a couple of wild burros near Aberdeen. If drivers stop near the café and honk their horns, the wild burros will come looking for leftovers, preferably salads. Generally, Northern Owens Valley does not have wild burros, but sometimes they can be spotted at the southern end.

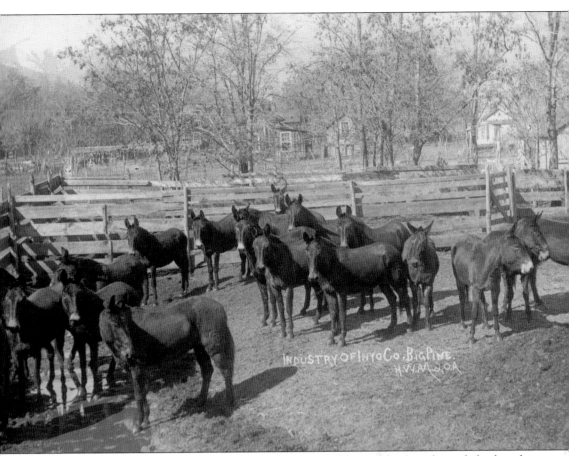

Cross a horse with a burro, and its enchanting offspring will be a mule. A mule is a hybrid, and while he cannot reproduce, he has admirable attributes. A mule will not overeat and drinks water less often than his glamorous counterpart, the horse. It can also be said that the dumbest mule is smarter than the smartest horse. He learns fast and has a sense of self-preservation, whereas the horse generally has the flight instinct. If stuck in a bog, the mule will not fight it; the horse will, getting himself into worse trouble. The mule's bone structure is bigger than a horse, and therefore so is its musculature, making him much stronger. This photograph depicts a common sight in the Owens Valley during the winter; packers bring their mules to the valley to escape the harsh mountain snow. (Harry Mendenhall.)

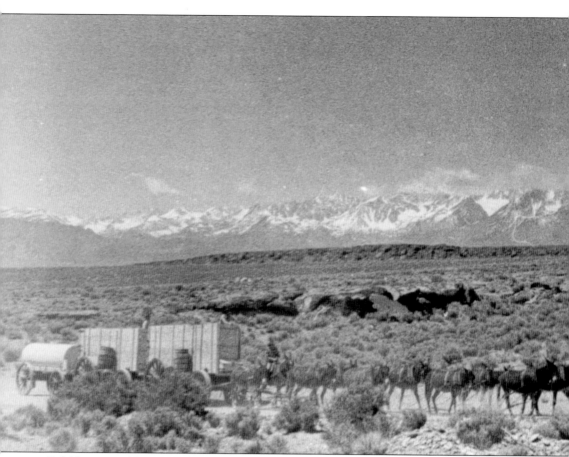

Bob Tanner and his 20-mule team travel along the Fish Slough Road with borax wagons that are 130 to 140 years old. The seven-foot wheels tower over a man's head. Each animal weighs between 1,000 and 1,300 pound, and 20 of these critters can pull a payload of over 30 tons along sandy and rutted roads. The most aggressive and smartest of these equines are at the front as

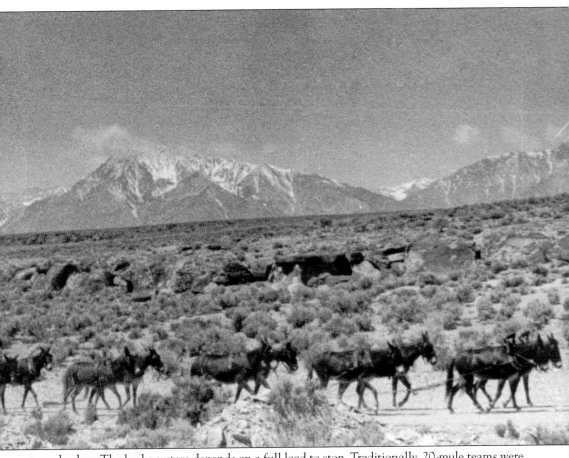

team leaders. The brake system depends on a full load to stop. Traditionally, 20-mule teams were used in the Owens Valley to carry ore, freight, and lumber. The Tanner family often participates in the Mule Days Parade with their teams and wagons. It is quite a spectacle to see them in the parade along with the Priefert Percherons and the Budweiser Clydesdales.

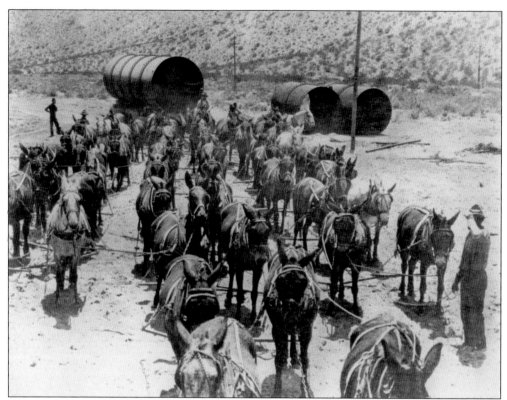

Several muleskinners direct a 40-mule team as they pull a section of aqueduct pipe while working on the Owens Valley–Los Angeles aqueduct. This is a rare scene today but not in bygone times, when mule teams were the truck engines of their day. (Los Angeles Department of Water and Power.)

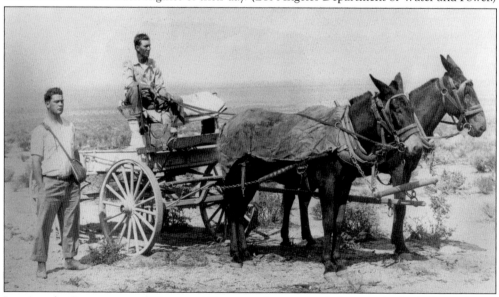

Los Angeles Department of Water and Power employees travel through the high desert during the hot summer near Bishop. The unidentified fellow on the left is carrying a canteen. The mules are covered with pieces of wet burlap to keep them cool.

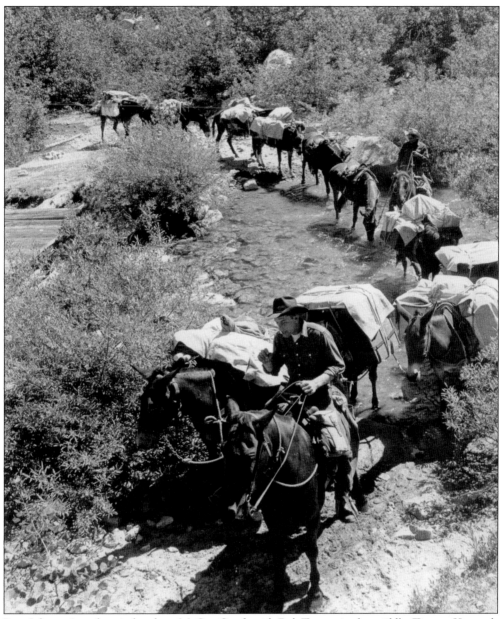

Russ Johnson's pack train heads up McGee Creek with Bob Tanner in the middle. Tanner, Kenneth Partridge, and others started Mule Days. There was a contest in the middle of Bishop's Main Street to see who could pack his mules the fastest, and that was the beginning of this Memorial Day weekend event. Mules have been used for thousands of years as work animals for mines, cargo companies, lumber outfits, cavalry brigades, and farms. These days, they can be seen carrying gear up to the high country for tourists. There is still lots of talk about mules being stubborn. One mule owner told the authors that if a mule develops bad habits, "You might as well slab 'em up and stick 'em in your freezer." However, Tanner suggests they become stubborn through bad training and being smarter than the handler. Their stubborn streak may also be because they have a built-in tendency to avoid danger. At one time, there were 41 pack stations on the Eastside. Now there are about 16. (Russ Johnson.)

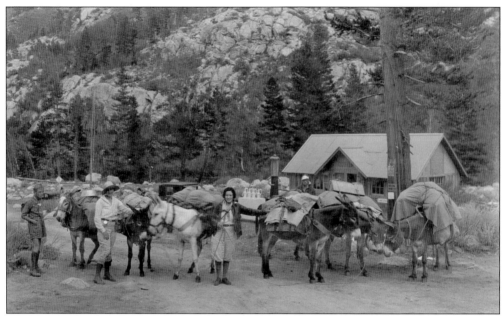

At Parcher's Rainbow Camp (c. 1930) four campers are ready to head up the mountain with burros to carry their heavy gear. Burros can pack about 20 percent of their body weight, ranging from 51 to 64 kilograms. It is a good thing the burros were carrying their gear because camping equipment was much heavier in those days. (Burton Frasher.)

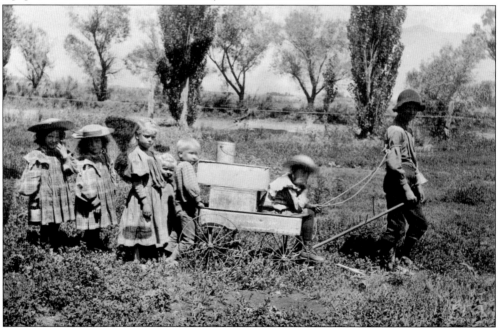

The Yaney family had both cattle and sheep and used pack trains to carry supplies. Yaney and Wey children are playing pack train. Guy Wey is the lead "mule," so there is a bell around his neck. Next comes the driver of a loaded wagon, followed by the pack "animals," the first three being Wey children with Teeny and Tony bringing up the rear. The pack "animals" are all packing something.

California governor Ronald Reagan rides a well tacked-up mule as grand marshal of the Mule Days Parade in 1974 toward the end of his second term. He had also been the host of television's *Death Valley Days* for many years, so Mule Days was a good fit for him. Reagan went on to be elected U.S. president in 1980, so riding this mule may have brought him good luck. (Curt Phillips.)

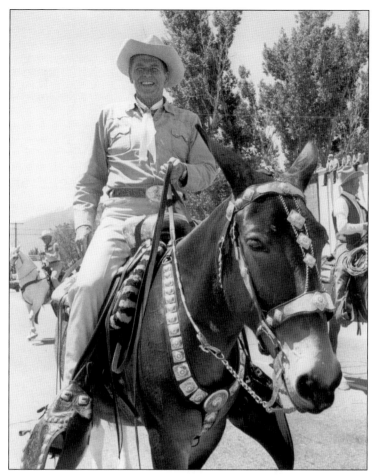

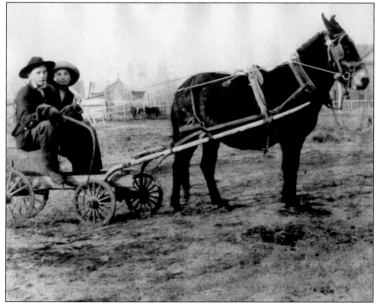

Cousins Lawrence Taylor (left), 11, and Ira Clark, 10, sit behind Jennie, the tolerant mule, in 1905. The cart was owned by Ira and the little mule by Lawrence. In the days when children had few toys and lots of chores, homemade carts and pets helped alleviate the tedium.

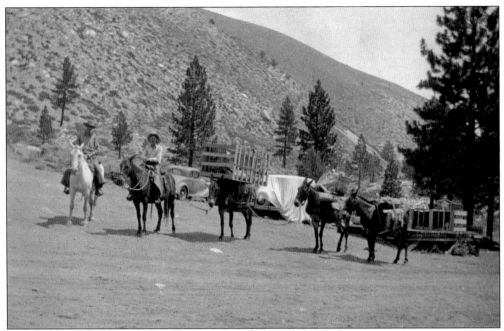

Kenneth Partridge (left) and Orville Houghton are heading up Big Pine Canyon to a cabin on moving day. The lead mule is burdened with a sofa and does not look all that keen about the idea, but no moving van could make this trip up the trail. The sturdiness and surefootedness of the mighty mule are displayed here. (Kenneth Partridge Collection.)

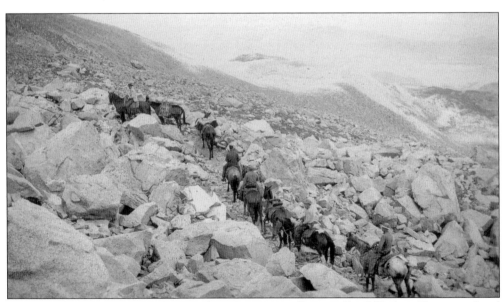

On December 12, 1941, Maj. Gen. Herbert Dargue was flying to Pearl Harbor, Hawaii, as head investigator of American preparedness after the bombing. The B-18 he piloted crashed into Birch Mountain. Kenneth Partridge leads a train with a mule carrying a litter behind him. Then come the military men, and finally Norman Clyde at the rear. They had to make 13 trips to bring out the bodies and debris.

Ten

LIFE ON THE RANGE

Cowboys need a break sometimes, and Orville Houghton (left) and Kenneth Partridge are no exception. This was taken at the Glacier Lodge Pack Station about 1940. Partridge's family owned the station, and Houghton worked there. Partridge and his son, Kenneth Jr., are still ranchers in Bishop today. Orville went on to work maintaining the roads, but he also did not forget his cowboy past and competed in many rodeos.

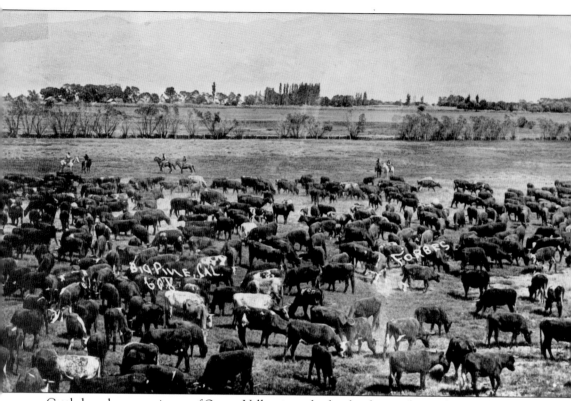

Cattle have been a mainstay of Owens Valley since the first herds were driven there in the middle of the 19th century. The cattlemen homesteaded the land, and as their herds increased, they acquired more land. They built canals to irrigate that turned the valley green. They diversified beyond cattle by planting orchards, vineyards, and vegetables. Longtime residents tell how lush the valley was when they were growing up. This 1920s image gives a hint of what the valley looked like at one time. Glimpses of yesteryear can still be seen in such places as Round Valley and the Warm Springs Road area. In Round Valley, stone walls still stand that early settlers built before barbed wire was invented in the 1870s. (A. A. Forbes.)

There are currently 127 cattle brands registered in Inyo County. Branding was generally done in the spring on the Partridge Ranch, which specialized in Herefords. Along with marking the calves, they would also vaccinate against anthrax, alkali poisoning, and black leg. Bull calves were unlucky enough to be castrated. Life can be tough for calves born in the winter: sometimes their little tails freeze off. In 1958, Bill Partridge (left), Pep Partridge (center), and Dick Moxley work with a disconsolate calf. Dehorning was done later in the year. Cattle were generally sold to markets in the fall. The Yribarren family now owns the Partridge Ranch. Two centuries ago, it would take steers four years to be ready for market. With selective breeding started by Robert Bakewell during the British Agricultural Revolution, the number was reduced to two years. Hereford cattle are not as popular any longer in the United States because, with their white faces, they are more susceptible to pinkeye. (Photograph by Willard Milligan.)

Cowboys stop for dinner. They are, from left to right, George Watterson, Jess Chance, Floyd Phillips, Gus Cashbaugh, and Jim Nicholls. Dinner was really lunch. But it was a big affair with lots of calories to get them through the rest of the day. Life on the range was not very glamorous; it was mostly hard work.

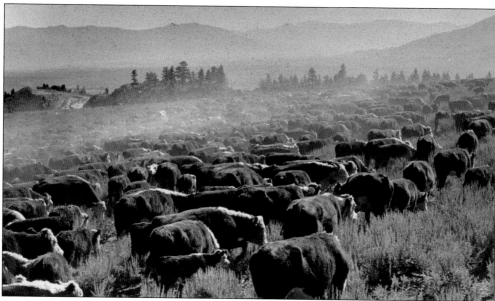

Cattle are being driven down Sherwin Grade in the fall. In the early summer, the reverse happens. This practice is called transhumance, where cattle are moved to better summer pastures, which also saves the ranch's lower elevation pasture for winter feeding. If the rancher does not watch them, sometimes the cows start the trek on their own to find better grazing.

Charles Partridge snapped this photograph of four of his children—(from left to right) Helen, little Pep sitting on a post, Bill, and Charles Jr.—working in the cornfield in the autumn of 1930. Farm children rested when they went to school. Corn picking was not an easy task, as the dried corn husks would cut their hands. Pep later said, "You went to work as soon as you could pick up a shovel.",

In 1948 Phil Moxley was a high school student who went to San Francisco's Cow Palace with the Future Farmers of America. In a calf scramble, he won this heifer. He had to raise it and take it back the next year for judging. This was at a time before there was a livestock show in Bishop. Phil went on to become Bishop's fire chief.

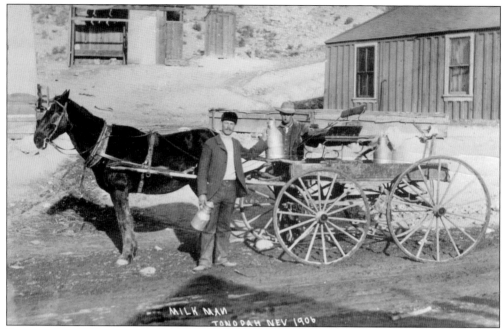

Seen in this 1906 photograph, Allie Shelly (left), Bishop milkman, had a long-distance milk run that went all the way to Tonopah. When this business went broke in 1915, he sold his dairy, losing a fortune. Shelly kept 200 beehives and was sworn in as Inyo County apiary inspector. In 1943, Shelly sold 289 5-gallon cans of honey to an agricultural product distributor for $2,081. Allie Shelly died in 1964.

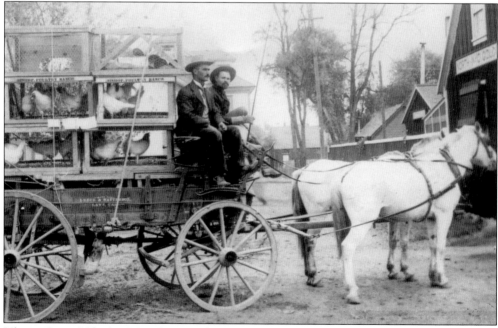

Ulysses Grant "Chicken" Smith sits at the left on the little freight wagon delivering his chickens from the Bishop Poultry Farm around 1900. U. G. (as he was better known) went on to open a large Buick and Chevrolet dealership in Bishop.

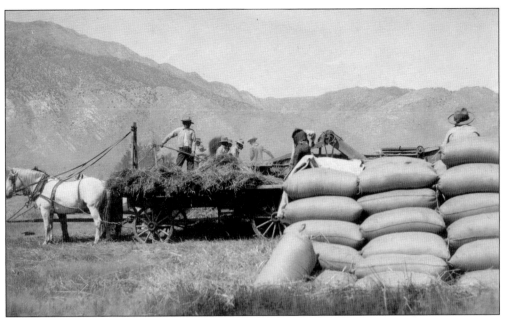

Agricultural output peaked in the Owens Valley about 1912; Bishop grain farmers grew large amounts of wheat, oats, barley, and corn. In these images, threshing crews are at work near Bishop. Grain harvesters generally labored in August or September and worked their way south toward Big Pine. The grain sacks were made at San Quentin by inmates. Threshing crews were headed by people such as Hampton, Yandell, or Rowan. Charles Olds had a large team that worked south of Bishop. In later years, Olds was the foreman on county road maintenance crews.

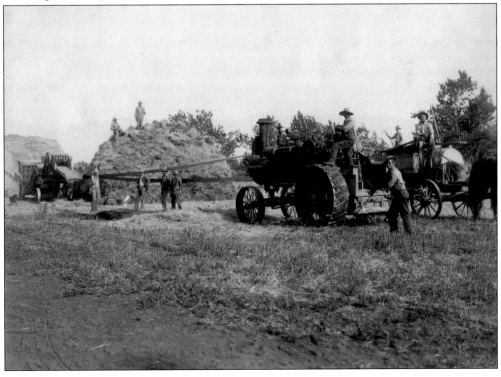

While Inyo-ites and tourists relax at the Mill Pond Festival, they might take a look around at the remains of the silo and foundations of the 2,000-acre ranch that once stood on the site. This was the Abelour Ranch founded by A. W. Longley from Chicago and managed by William Tinder. Besides sheep, like the ones pictured below in a c. 1910 photograph by A. A. Forbes, the family raised purebred livestock such as Holstein cattle. Longley built a dam on Horton Creek for irrigation purposes. The other image shows the ranch as it appeared in a Will Rogers film. The property was sold to the Southern Sierra Power Company in 1921, then to the Department of Water and Power. The Inyo Lumber Company leased it for a sawmill, and the business used the building for employee housing. It was later destroyed by flames. (Above, Cathy Yribarren.)

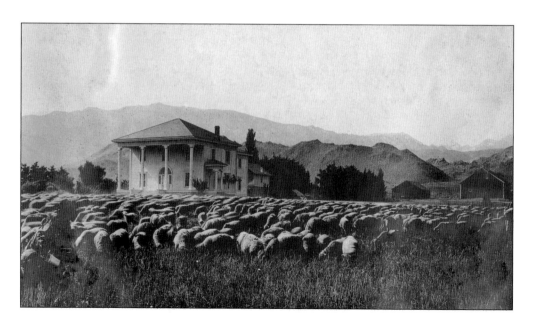

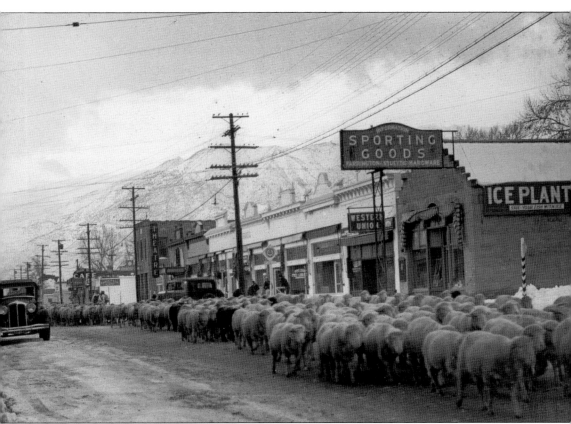

Although cattle were the mainstay of agriculture in the Owens Valley, sheep were also important. In 1920, the state took a tally of 43,542 sheep in Inyo County. In 2007, the total was a mere 97. There were not any major cattle-sheep range wars in the area as there were in Colorado or Wyoming, but certainly there were pasture disagreements. Many of the sheepherders were Basque who came from the Pyrenees Mountains in Spain and France. This is the basis for the famous Sheepherder bread that is sold at Schat's bakery today. Sheep can still be seen in the valley but mainly in the high country during the summer. Sheep being driven north on Main Street in 1937 was somewhat unusual but not uncommon. Sheep pens were located between Redding and Black Canyons at the foot of the White Mountains. At this location, shearing was done by Mexican crews at a price per head. Drives were made mostly on the east side of the Owens River. There is only one Basque sheepherder left who still drives his sheep from Bakersfield to Mono County.

"Lunch Time" — H.W.M.

This scene may look unusual to some people, but to those who have lived on farms such sights are not as odd as one might think. Nature provides. These three happy hogs can pig-out, and no one is asking for anyone's ID.

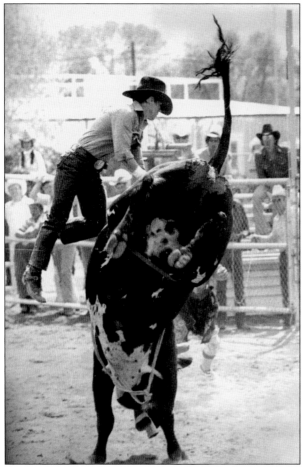

The rodeo has long been an amateur and professional community activity among local cowboys, especially during the Labor Day Homecoming Celebration. Attendees can expect to see team roping, broncs, barrel racing, and everyone's favorite, bull riding. Bishop also now plays host to the California State High School Rodeo championship every summer. (Willard Milligan.)

Raised just south of Bishop, Enid Ashworth poses on her Coso Range mustang, Krispy, which she personally trained. Krispy was a great horse but had a rough trot. Wild mustangs have not been prevalent in the northern Owens Valley, but horse lovers adopt them for their surefooted attributes and trail stability. They are compact, intelligent, and sturdy. (Partridge family collection.)

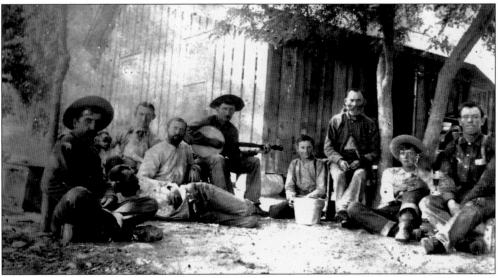

These men take a break from ranch work in 1899. They are, from left to right, Cal Everett, Jed Carpenter (lying down), Frank Partridge, Fred Smith, Harley Sanders (with banjo), George Partridge, Philip S. Partridge, Charles Scott, and Rawley Gish. This was on the Philip Partridge homestead, 8 miles south of Bishop, which was a cattle operation. Partridge was an immigrant from Canada and brought his family here on the Slim Princess in 1888.

This Inyo family is unidentified, but their parlor was typical of 1904. Family members are dressed in their Sunday best. The parlor or sitting room was saved for visitors and formal family gatherings. Ranch houses for the most part were more functional and less ornate. In the days before the telephone, it was customary to call on people usually in the afternoon. If someone came to visit a family such as this, he or she would leave a calling card on the table. This parlor (below) was at the Shelly home just south of Bishop at Shelly Hill.

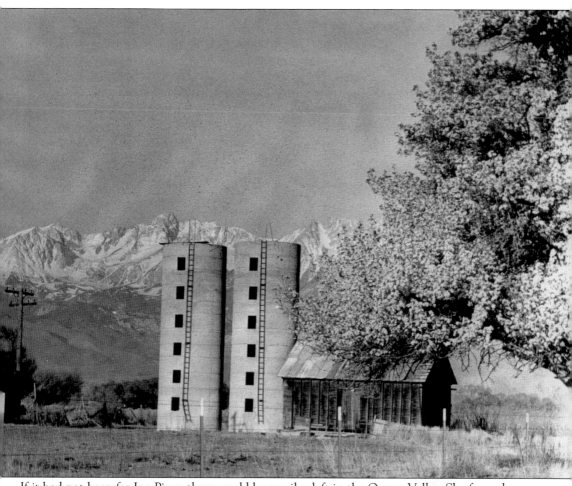

If it had not been for Ina Piper, there would be no silos left in the Owens Valley. She formed a committee in the 1960s and appealed to local governments for their aid in halting the demolitions. They successfully got an injunction to stop the Department of Water and Power from tearing down the historic edifices. Silos are some of the few remnants of the original farm locations from the early 20th century. Locally, the tall structures were first built in Round Valley and made of stone. It is said that the first silo west of the Mississippi River was built there by William Roberts in 1898. Concrete silos in Owens Valley were subsequently built by A. O. Adams for $400 each, and his signature and date are usually on the floor of each silo. Horse teams and derricks lifted 3-foot-tall circular forms into place, which were then filled with river sand and cement. Though 29 silos remain in the region, the Round Valley stone silos fell down even after efforts were made to save them.

From 1908 to 1913, construction of the Owens Valley–Los Angeles Aqueduct took place. In order to own the water rights in the Owens Valley, the City of Los Angeles bought most of the farms and ranches. J. D. Black, owner of Black's Cash Store in Bishop, photographed what was left of some of the properties. On the reverse side of the house image (above), he wrote, "Formerly Hart Home. Purchased 1923." On the back of the orchard image (below), he wrote, "What is left of old Perry Orchard." In the early wave of sales, owners received little. But in the last round of purchases, owners obtained what was perceived by many to be a fair price. Remaining valley residents tore down the vacated structures for use in building and corral construction. (Department of Archives and Special Collections, William H. Hannon Library, Loyola Marymount University.)

BIBLIOGRAPHY

Bahr, Diana Meyers. *Viola Martinez, California Paiute: Living in Two Worlds.* Norman, Oklahoma: University of Oklahoma Press, 2003.

www.cagenweb.com/inyo

Chalfant, W. A. *The Story of Inyo.* Bishop, California: Chalfant Press, 1933.

Charles Partridge. Diary. 1910–1937.

www.historysanjose.org

Inyo Register. Bishop: Horizon California Publications, 1883–present.

Motor Touring in the Eastern Sierra Including Death Valley. Bureau of Land Management and Eastern Sierra Interpretive Association, et al.

Our Heritage in District 9. California Department of Transportation, 1966.

www.owensvalleyhistory.com

Walter, Nancy Peterson. "The Interchange Between the Paiute-Shoshone of the Owens Valley, California, and the City of Los Angeles Dept. of Water and Power." Paper presented at American Indian Policy Conference, UCLA, February 21–22, 1985.

Wilkinson, Katie. "Ghosts of Fish Slough, U.S. Bureau of Land Management." *Inyo Register.* July 29, 1984.

ABOUT THE ORGANIZATION

The Laws Railroad Museum and Historic Site is dedicated to preserving the heritage of Owens Valley and the Eastern Sierra. It has 11 acres of unique structures and exhibits, including the original station depot, agent's house, and Slim Princess engine no. 9. It is located just off of Highway 6, four miles northeast of Bishop on Silver Canyon Road, and is open daily from 10:00 a.m. to 4:00 p.m. More information is available at www.lawsmuseum.org or on Facebook.

www.arcadiapublishing.com

Discover books about the town where you grew up, the cities where your friends and families live, the town where your parents met, or even that retirement spot you've been dreaming about. Our Web site provides history lovers with exclusive deals, advanced notification about new titles, e-mail alerts of author events, and much more.

MADE IN THE USA

Arcadia Publishing, the leading local history publisher in the United States, is committed to making history accessible and meaningful through publishing books that celebrate and preserve the heritage of America's people and places. Consistent with our mission to preserve history on a local level, this book was printed in South Carolina on American-made paper and manufactured entirely in the United States.

This book carries the accredited Forest Stewardship Council (FSC) label and is printed on 100 percent FSC-certified paper. Products carrying the FSC label are independently certified to assure consumers that they come from forests that are managed to meet the social, economic, and ecological needs of present and future generations.

FSC
Mixed Sources
Product group from well-managed forests and other controlled sources

Cert no. SW-COC-001530
www.fsc.org
© 1996 Forest Stewardship Council

Find Your Place in History.